NATIONAL GALLERY OF AUSTRALIA

An introduction
to the collection

CONTENTS

Produced by the Publications Department of the National Gallery of Australia, Canberra
Designers: Griffiths & Young, Canberra
Editor: Karen Leary

Colour separations by ColourboxDigital, Perth, WA
Printed by Lamb Printers, Perth, WA

Cataloguing-in-Publication data
National Gallery of Australia.
National Gallery of Australia: an introduction to the collection.
ISBN 0 672 13093 0.

1. Australian National Gallery - Exhibitions.
2. Art museums - Australian Capital Territory - Canberra - Exhibitions. I Title.
708.99471

Cover
Fernand Léger *Trapeze artists* 1954 (detail).

Title pages
Australian Art: Margaret Preston *Flying over the Shoalhaven River* 1942 (detail).
Aboriginal Art: Jack Wunuwun *Barnumbirr the Morning Star* 1987 (detail).
International Art: Willem de Kooning *Woman V* 1952–53 (detail).
Asian Art: Munakata Shiko *Guardians of east and west* 1953 (detail).

All works illustrated are in the National Collection, at the National Gallery of Australia, Canberra. Measurements are given in centimetres, height x width (x depth where applicable).

PREFACE

THE NATIONAL GALLERY OF AUSTRALIA HAS ALREADY established a large collection of more than 100,000 works of art although it first opened its doors to the public as recently as 1982. Since that time, the Gallery has gained a significant position in the cultural life of Australia and has begun to promote its collections to an international audience. The people of Australia, in particular those of the Canberra region, have developed a strong loyalty to their Gallery, and our wider national mandate has also been served with a fine series of travelling exhibitions that have toured to venues throughout Australia. Major loan exhibitions in Canberra and those we have curated abroad have brought members of staff from the world's most important galleries into contact with the National Gallery of Australia to mutual benefit.

The advent of on-line global access electronic services has been embraced by the Gallery and, as part of our publications program, we are also updating this general introduction to the collection.

This book presents a selection of some of the finest and most interesting objects in the Gallery's collection. The range is admirable and the quality is high indeed. The Gallery's collecting policy has been an ambitious one and this tradition will be maintained. It is with confidence and enthusiasm that we plan towards a new century and the further development of the national art collection.

Brian Kennedy
Director
National Gallery of Australia

INTRODUCTION

THIS BOOK INCLUDES A SELECTION OF HIGHLIGHTS OF THE collections of the National Gallery of Australia and seeks to show the range and balance of the collections across the four main areas — Australian art, Aboriginal and Torres Strait Islander art, Asian art, and International art. There are, of course, many fine works which have not been included. Nevertheless, the book indicates the balance of the collections, and something of the unique character of the National Gallery of Australia. These collections belong to the people of Australia and are preserved and presented for their enjoyment and education.

The National Gallery of Australia, a relatively young collection, opened to the public in 1982. The Commonwealth had begun collecting works of art, however, shortly after its establishment in 1901. In 1912 the Government set up two bodies — the Historic Memorials Committee (to commission portraits of prominent politicians and public figures) and the Commonwealth Art Advisory Board as an expert body to advise the Government. From 1914 the Committee was responsible for the commissioning and acquisition of works of Australian art for the Federal Government. It continued to do so until 1973 with the establishment of the National Gallery.

A crucial step in the formation of the National Gallery was the establishment, in 1965, of a National Art Gallery Committee of Inquiry. The Chairman of this Committee, Sir Daryl Lindsay, submitted a report to the Government in 1966 which led to the Gallery's establishment. Lindsay's report recommended that a future Gallery should focus its collecting on modern art, Australian art and the art of south and east Asia, but added the proviso that the Gallery should always allow for the possibility of seizing opportunities to acquire any works which may become available, irrespective of the time, place or genre.

The Gallery building was begun in 1973 and collecting began in earnest with the establishment of an Art Acquisitions Committee in the same year. Collecting was carried out at a rate remarkable for any Australian public art collection.

In 1975 the Gallery was formally established with the passage of the National Gallery Act. At that stage the Gallery's name was the Australian National Gallery; the present name was adopted in October 1992. At the time of the proclamation of the National Gallery Act in 1976 there were some 23,000 items in the collection. At the same time the Gallery published an Acquisitions Policy which gave broad general direction to the building up of collections.

Australian art has always been at the core of the National Gallery's collections. In many ways the collections of art from outside Australia have been built with the desire to relate the art of the world to the art of Australia. The Australian collections are deep and broad-ranging, including not only paintings, sculptures, prints and drawings but also photographs, decorative arts, theatre designs and posters. It has always been the aim of these collections to include not only material for a comprehensive historical display of Australian art, but also a study collection through which researchers may understand better the story of Australian art.

Australian art includes the art of Australia's indigenous people — Aboriginal people and Torres Strait Islanders. Unlike many museum collections, the National Gallery's collection is not ethnographically focused, but sees art as both an integral part of the expression of Aboriginal tradition, belief and societal structures and as a contemporary expression of cultural and political identity.

Unlike the collections of Australian art, the collections of non-Australian art do not seek comprehensiveness, but rather indicative quality. Individual works have been acquired for their exemplary nature; there are also several parts of the collection which are deep and important — for example the collection of costumes and designs for the Russian Ballets and the collections of international prints and photographs.

In the field of Asian art, the Gallery's greatest strength is the South-East Asian collections, particularly of Buddhist sculpture from those regions, and of textiles.

The Gallery has built its collections through applying funds provided by the Commonwealth Government and as a result of a number of generous benefactions. In 1975 the Gallery received a gift from Arthur Boyd which included the great bulk of the artist's work across a range of media, from paintings to tapestries. In 1977 Sunday Reed gave the Gallery Sidney Nolan's seminal Ned Kelly series; in 1989 Gordon Darling endowed the Gallery with a purchase fund to buy contemporary Australasian prints; in 1994 Tony and Carol Berg donated a collection of major German expressionist prints; in 1995 T.T. Tsui gave the Gallery a collection of Chinese funerary art. James O. Fairfax has also given major paintings to the Australian collection as have Joseph Brown, and Benno Schmidt and Mrs Schmidt. Victor and Loti Smorgon have also donated funds for the purchase of works of art through the Gallery Foundation, and Dr Orde Poynton has been a consistent supporter of the collection of international prints and illustrated books. The names of many other generous donors will be found in the credit lines of a number of works illustrated in this book.

The national collections (which include those of the National Gallery, but also of our sister institutions, such as the National Library of Australia, the National Museum of Australia and the Australian War Memorial), belong to the people of Australia. The collections are there for all to enjoy, cherish and learn from. It is the intention of the Gallery to make the collections as widely appreciated as possible both in Australia and overseas.

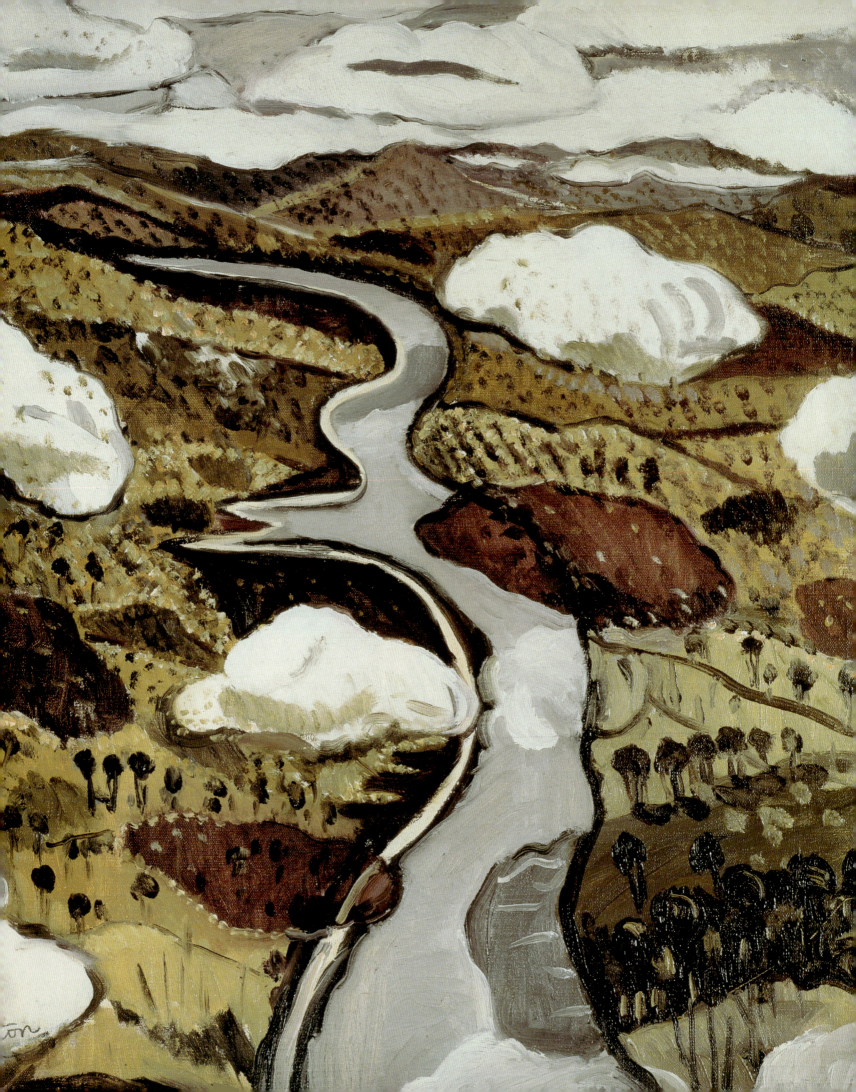

AUSTRALIAN ART

The collections of Australian art are of central importance within the various collections of the National Gallery of Australia. Australian art, in its completely inclusive sense embracing Aboriginal and non-indigenous art, is the visual culture which has developed in response to the Australian environment, to a diversity of international influences and to the specific flavour and quality of living in this country.

The collection is diverse in range and large in scale. It incorporates works acquired by Australian governments before the establishment of the National Gallery of Australia and the results of wide-ranging collecting over the past two decades. The collection encompasses work in many media — paintings and sculpture, prints and drawings, photographs, the decorative arts, sketchbooks, posters and installation art. The variety of form represented is the result of the Gallery's policy since the 1970s that the collection should present the national art heritage of Australia in the widest possible sense.

The collection incorporates art made in Australia or about Australian subjects since European settlement in 1788. The greatest strengths of the collection are the 20th century works because the Gallery has always seen its collection in relation to the rich and extensive collections of earlier visual material held in the National Library of Australia. With the permanent inclusion of a number of highly important colonial paintings from the historical collection built up by Rex Nan Kivell (held in the National Library of Australia) the National Gallery is able to present a continuous and comprehensive story of Australian art over the past two centuries.

The art of Europeans in Australia during the colony's early decades is dominated by three themes: natural history, the landscape and Aboriginal people, all of which were aspects of the novelty of this 'new world'. J.W. Lewin's book of Australian birds (1813) is a beautiful attempt to present and classify Australian flora and fauna. Many works of early colonial art were dedicated to European scientific interest. Landscapes offered greater artistic possibilities than natural history illustration, however scientific accuracy was a requirement for most works until the 1860s. Eugene von Guérard's *North-east view from the northern top of Mount Kosciusko* (1863) is typical — the artist created a geological, geographical record, yet also suggested the striking mood of Australia's highest mountain range.

Augustus Earle's *Bungaree* (c.1826), Benjamin Law's busts of Woureddy and Trucaninny (1836), and John Glover's *The Bath of Diana* (1837) show a range of approaches to the depiction of Aboriginal people. While much colonial art caricatured a people whose culture the colonisers failed to understand, these works reveal more complex relationships between the colonial framework and individuals within it.

As European colonisation of Australia expanded, the depiction of landscape became the dominant defining theme in Australian art. Flora and fauna featured in the decorative arts, whilst landscape became the focus of what has been widely regarded as the national school of Australian painting, the Heidelberg School. The Gallery's extensive collection of works by Heidelberg School artists — such as Tom Roberts, Charles Conder and Frederick McCubbin — includes several from the famous 9 x 5 Impression Exhibition of 1889 which declared a new, direct and subjective approach to landscape motifs. The addition of Arthur Streeton's *Golden summer, Eaglemont* (1889) to the collection gave the National Gallery a major Australian icon.

The history of Australian painting must be seen in relation to the development of photography. Bernard Otto Holtermann's *Panorama of Sydney Harbour and suburbs from the north shore* (1875) is a high point of a collection that begins in 1845 with the documentation of nature, Aboriginal and settlers' lives, and expeditions. The comprehensive collection of major 20th century photographers such as Frank Hurley, Harold Cazneaux, Olive Cotton and Max Dupain shows the rich history of Australian photography, from documentation to abstraction.

Early 20th century Australian art is often treated as the story of expatriate experience; Australian artists studying and working in Europe. There is another dimension, however, to the domestic Edwardian art world — the determined integration of the decorative arts and the applied arts into the wider art world.

As in the 19th century, the 20th century continues the preoccupation with the Australian landscape. Margaret Preston's *Flying over the Shoalhaven River* (1942) and Sidney Nolan's Ned Kelly series (1945–47) are both major statements about the landscape. Preston's fascination with the new perception of the landscape possible from the air is combined with her desire to create a distinctively Australian art by using a palette derived from earth colours used by Aboriginal artists, while Nolan seeks to explore the landscape through, as he put it, painting the stories that came out of the landscape. Nolan's paintings, along with a large collection of his drawings, constitute an important part of the Gallery's representation of the art of postwar Australia. Works by Arthur Boyd — a large and comprehensive group given by the artist to the Gallery in 1975 — are another great strength of the collection, along with the works of John Perceval, Albert Tucker and Joy Hester.

While landscape continues in the 20th century to be a significant defining motif in Australian art, the forms of our visual culture have become more wide ranging. Sculpture is well represented in the collection with both small sculptures, such as those of Bertram Mackennal and Robert Klippel and large scale works, such as the monumental *Virginia* (1970–73) by Clement Meadmore.

The Australian print collection has been greatly enhanced through the Gordon Darling Australasian Print Fund.

New Zealand Art

It has always been an important part of the Gallery's collecting policy to have regard for the visual cultures of our near neighbours, particularly New Zealand. In the 19th century there was a great deal of two-way cultural traffic across the Tasman Sea. The Gallery's collection of Maori art is small but contains some significant sculptures. The Gallery also holds some masterworks by Colin McCahon, who is widely regarded as New Zealand's greatest 20th century painter. As with Australian art, the Gallery seeks to add to the New Zealand collection important works by living artists. One of these, Neil Dawson's *Globe* (1989), suspended between the Gallery and the High Court of Australia, has come to be a recognisable symbol for the Gallery. The positioning of the work outside the building resonates with the imperative embodied within the collections — that they bring the world to Australians, and present Australian art in relation to the art of the world.

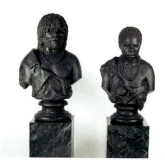

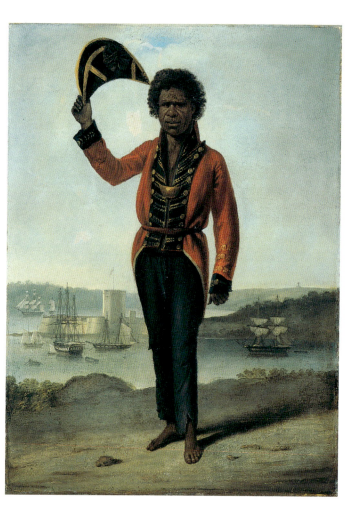

John William Lewin 1770–1819
King honey-sucker (Pl. VI)
etching, hand-coloured
28.0 x 21.8 cm
from *Birds of New South Wales and their Natural History* (Sydney: 1813)
bound book of 18 etchings,
hand-coloured and letterpress
on paper

John William Lewin was born in England in 1770 into a family that specialised in natural history illustration. He arrived in Australia in 1801 and was the first artist to produce prints in New South Wales. *Birds of New South Wales and their Natural History* (1813) was the first non-Government book published in the colony. Lewin finished the plates for the book between December 1804 and February 1805, and a small edition was published in England in 1807. The National Gallery of Australia's copy of *Birds of New South Wales and their Natural History* is one of 13 books known to have been produced in the Sydney edition of 1813.

Lewin's distinctive style of closely cropped and often asymmetrical compositions, combined with his naively unscientific yet poetic texts, has ensured the book's place in Australian visual history. It is not only one of the most significant colonial publications, but also one of the most beautiful.

Augustus Earle 1793–c.1838
Bungaree, a native of New South Wales
c.1826
oil on canvas
69.0 x 50.9 cm
Rex Nan Kivell Collection, National Library of Australia and National Gallery of Australia, Canberra

Augustus Earle came to Australia in 1825 and quickly established himself as Sydney's leading artist, and was given many commissions, including a number of society portraits.

This portrait of Bungaree, an Aborigine from Broken Bay who was a Sydney identity for over 20 years, may be the first 'high art' portrait of an Australian Aboriginal subject. The tragedy of Aboriginal dispossession at the hands of the European colonisers is made more acute by the depiction of

Bungaree in a pose traditional to European art. The poignancy of his cast-off military uniform and melancholy salute is underscored by the enduring dignity that Earle conveys. In the background of the work can be seen Fort Macquarie (on Bennelong Point, now the site of the Sydney Opera House).

A contemporary account describes Bungaree's ritual welcoming of ships in Sydney Harbour:
[H]e makes one measured stride from the gangway; then turning round to the quarter-deck, lifts his beaver with his right hand a full foot from his head (with all the grace and ease of a court exquisite) and carrying it slowly and solemnly to a full arm's-length, lowers it in a gentle and most dignified manner down to the very deck, following up this motion by an inflection of the body almost equally profound.

Benjamin Law 1807–1890
Woureddy, an Aboriginal chief of Van Diemen's Land 1836
cast and patinated plaster
75.0 x 48.3 x 27.0 cm
Trucaninny, wife of Woureddy 1836
cast and patinated plaster
66.0 x 42.5 x 25.7 cm

Benjamin Law was the first sculptor of any consequence to work in Australia; the portrait busts of Woureddy and Trucaninny are the only surviving examples of the work he produced in this country. Law made around 30 casts of the busts and advertised them for sale in bronze or stone finish at four guineas each.

The style of these portrait busts follows the classical tradition — but instead of classical Roman drapery, Woureddy and Trucaninny wear kangaroo skin cloaks. The most striking feature of the portraits is their naturalism — we experience an extraordinary sense of the subjects themselves. It is likely that the portraits were made from life, on commission from George Augustus Robinson, the 'protector' of the Aborigines of Van Diemen's Land.

In the past such works were held in museums for their historical and ethnographic interest. Yet these portrait busts are masterpieces of colonial art, of enormous historical and cultural significance, and rare in their humanity and empathy with their subjects.

John Glover 1767–1849
The Bath of Diana, Van Diemen's Land
1837
oil on canvas
76.0 x 114.0 cm

John Glover's *The Bath of Diana* is an important painting of Australia's colonial period. By the time Glover arrived in Van Diemen's Land in 1831, it was too late to witness Aboriginal people living in groups in the bush, as he depicts in this painting. Following European settlement, genocide and disease had destroyed much of the indigenous population of the island. After the failure of the 'black line' policy of 1828, which sought to rid the settled areas of Aborigines, a policy of 'conciliation' was instituted under George Augustus Robinson, who rounded up Aborigines for resettlement. By the 1830s most of the island's remaining Aborigines were incarcerated on Flinders Island.

In its sombre mood *The Bath of Diana* reflects the widespread pessimism of the 1830s that the Tasmanian Aborigines were a dying race. Glover couches this fatalism within Greek myth — that of Actaeon the hunter and Diana the goddess. Actaeon (seen hiding behind the rocks) is caught spying upon Diana as she bathes. Diana punishes Actaeon for his transgression by turning him into a stag; he is then set upon and eaten by his own dogs. It has been noted that in this painting Glover portrays 'the last moment of order and tranquility before invasion is apprehended and violence and mayhem break out'.

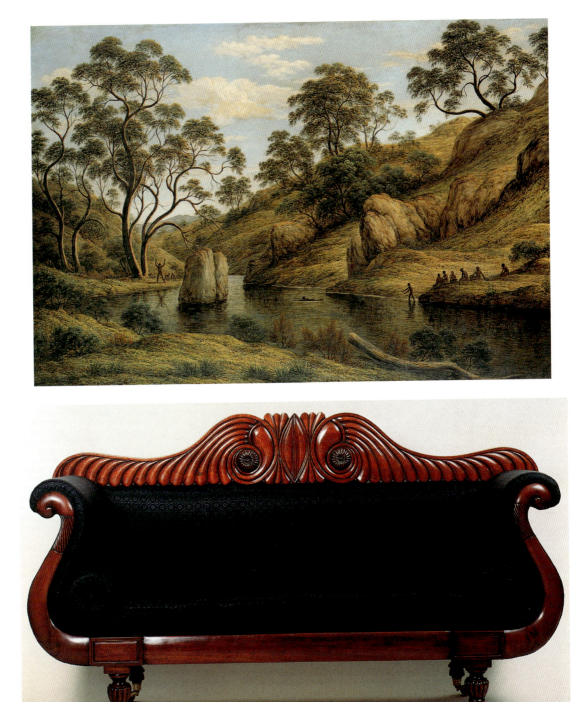

Artist unknown
Sofa c.1840
cedar (*Toona ciliata*), brass and ceramic casters, horsehair upholstery, silk
115.0 x 210.0 x 56.0 cm

This lyre-shaped sofa, made in Tasmania from Australian red cedar, is a fine example of the neo-classical style popular in Australia and England from the 1820s to the 1840s. Australian red cedar was an extremely popular timber in early Australian colonies, not only because it was plentiful, but because it was easy to cure,

resisted insect attack and was readily polished to resemble European cedar (*Cedrus*). Fabric woven from the manes and tails of horses (horsehair) was a luxury upholstery material in use since the mid 18th century. While the upholstery on this sofa is a modern replacement, it is consistent with the original design.

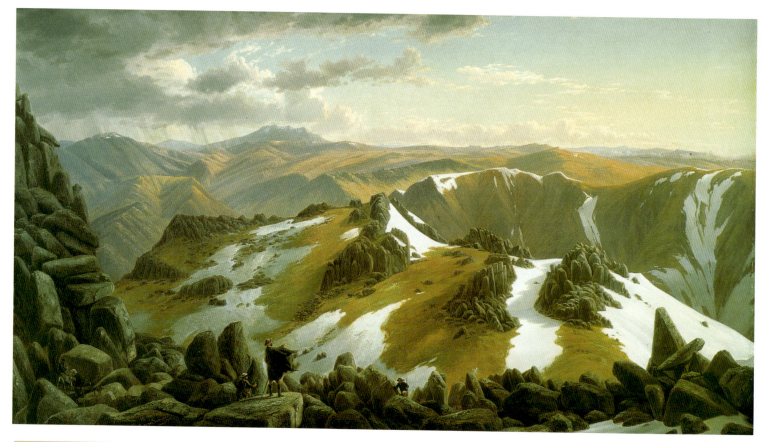

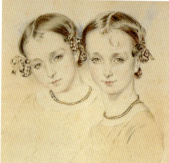

Thomas Griffiths Wainewright
1794–1847
The Cutmear twins, Jane and Lucy
c.1842
pencil, watercolour on paper
32.4 x 30.0 cm

Thomas Griffiths Wainewright was transported to Van Diemen's Land in 1837 for forgery. In 1844 he attempted to obtain a ticket-of-leave, but was unsuccessful and spent his last ailing years in Hobart. Before he was transported Wainewright had been a part of elegant literary society in London and his life has been the subject of stories and a novel.

Despite declining health during his 10 years in Hobart, Wainewright established a clientele for portrait drawings; his known output consists of more than 50 works. His finely detailed treatment of the face and hair and summary treatment of the clothing of the upper body shows him adopting the standard portrait drawing manner current in Great Britain from the 1790s. This drawing is among the best preserved of his works.

Wainewright's drawing of the Cutmear twins was made about the middle of the decade he spent in Hobart. Jane and Lucy were twin daughters of James Cutmear, the Gatekeeper of the Prisoners' Barracks. It is a delicate and moving work, which has an added poignancy when we learn that both girls succumbed to sickness in their youth; Jane died at the age of 12 from inflammation of the lungs and Lucy at age 21 of consumption.

Eugene von Guérard 1811–1901
North-east view from the northern top of Mount Kosciusko 1863
oil on canvas
66.5 x 116.8 cm

Eugene von Guérard arrived in Australia in 1852 and by 1854 had established a reputation as a leading landscape painter. He visited Mount Kosciuszko (which in von Guérard's day was spelt without the 'z') in November 1862, accompanying the German scientist Georg von Neumayer and his party, who were conducting a survey of variations in the earth's magnetic field, a significant factor in the patterns of meteorology and geography. Neumayer's detailed records make reference to von Guérard making a number of sketches during the demanding ascent and at the summit where the party was overtaken by a storm.

In this painting, which von Guérard constructed in his Melbourne studio from his sketches, the artist has combined a topographically accurate view with a romanticised vision which evokes the grandeur of the mountain landscape and the power of natural forces.

Bernard Otto Holtermann
1838–1885
Charles Bayliss 1850–1897
Panorama of Sydney Harbour and suburbs from the north shore 1875
from *Holtermann's Exposition New South Wales Scenery* (detail)
23 albumen silver photographs
each 152.0 x 91.0 cm

This photographic panorama by Bernard Holtermann and Charles Bayliss gives a continuous view of Sydney Harbour and its suburbs. The 23 individual photographs were printed from wet plate negatives measuring 152.0 x 91.0 cm — the largest recorded examples at the time.

The photographs were taken from a specially constructed observation tower at Holtermann's

4

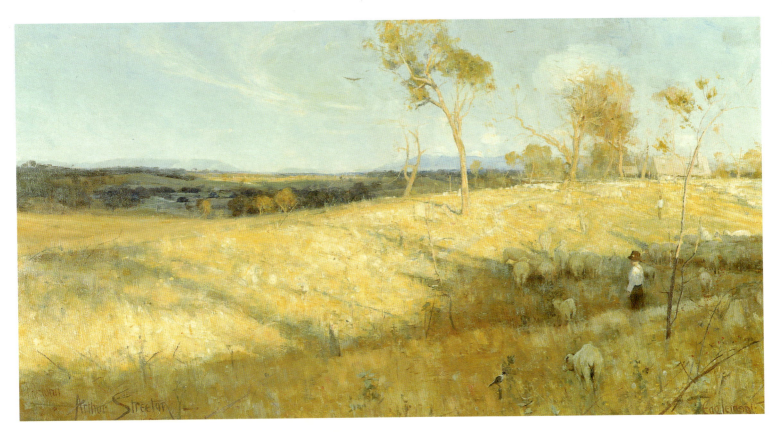

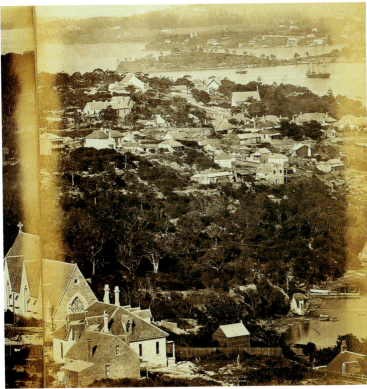

Arthur Streeton 1867–1943
Golden summer, Eaglemont 1889
oil on canvas
81.3 x 152.6 cm

Golden summer, Eaglemont is an Australian idyll, a poem to the Australian landscape. The painting celebrates an experience of the landscape which was one of leisured enjoyment. Eaglemont, on the outskirts of Melbourne, was a rural settlement in the 1880s.

Arthur Streeton and fellow artists Tom Roberts, Charles Conder and others painted regularly around Eaglemont and Heidelberg, sometimes on day trips, sometimes camping there.

Streeton made an initial oil sketch for this painting in full sunlight, on the spot overlooking the Yarra basin and the blue ranges of the east and north. The high key of his original impression is mellowed in the finished painting to what he called the 'coppery light' of a long afternoon; with the rising full moon and a halo of mare's-tail clouds.

The painting was greatly praised; it was exhibited at the Royal Academy in London, and was awarded a *Mention Honorable* at the Paris Salon in 1892.

home in Lavender Bay on Sydney's north shore. Holtermann exhibited the panorama at the Philadelphia Centennial Exhibition of 1876 and the Exposition Universelle in Paris in 1878. He hoped this pictorial record of the rapid development of the colony would encourage emigration to Australia.

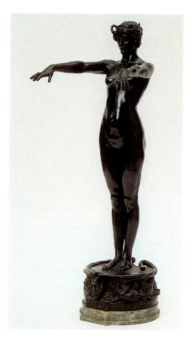

Bertram Mackennal 1863–1931
Circe 1892–93
cast and patinated bronze
height 58.0 cm
Bequest of Dr Don R. Scheumack

This is one of a number of small
versions of Bertram Mackennal's
celebrated sculpture of *Circe* —
the life-size plaster original was
exhibited for the first time in Paris
at the annual Salon of 1893.

A sorceress from classical Greek
mythology, Circe was a favourite
subject for turn-of-the-century artists
and is the embodiment of a female
archetype of alluring evil which was
then in vogue. Mackennal's *Circe*,
depicted in the act of casting a spell,
appears both sensual and sinister.
In the sculpture's mature athletic body,
with its high finish, the artist has
combined classical form and the
sinuous properties of Art Nouveau —
evident in the coiled snakes through
Circe's hair and around the pedestal.
The naked writhing figures around
the pedestal suggest a metaphor for
human sexuality as a state of
enchantment and submission. In its
synthesis of the psychological power
of the subject and classical sculptural
form, *Circe* was Mackennal's most
successful work.

Tom Roberts 1856–1931
In a corner on the Macintyre 1895
oil on canvas
71.1 x 86.4 cm

In a corner on the Macintyre was
painted at Newstead, near Inverell
in New South Wales. In this
area the bushranger Captain
Thunderbolt (Frederick Ward)
had operated some 30 years before.
Tom Roberts had gone to
Newstead with the idea of painting
a bushranging subject, and his
painting *Bailed up* 1895
(Art Gallery of New South Wales)
depicts Thunderbolt robbing the
Inverell–Armidale mail coach.
In a corner on the Macintyre was
re-titled 'The bushranger' by the
artist when the work was exhibited
in 1900 — and one reading of the
painting is that it depicts
Thunderbolt's last stand:

the bushranger shelters behind
a boulder to the left of the standing
horse; a trooper is visible at the top
of the cliff; the other troopers are
hidden, their presence is
announced only by the puffs
of smoke from their rifle fire.
However, the mood of the painting
is quiet rather than heroic and
Roberts appears to be more
interested in conveying the poetry
of the landscape than a story.

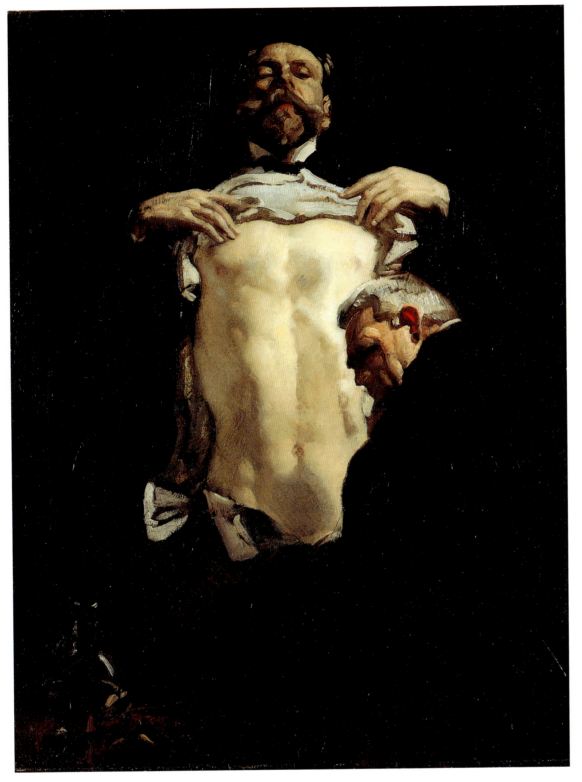

George W. Lambert 1873–1930
Chesham Street 1910
oil on canvas
60.0 x 49.5 cm

George Lambert spent 20 years
in England and had more success
there than most Australian
painters. He exhibited at the
Royal Academy, and was made
a member of the Academy in 1922.
Chesham Street shows the artist
being examined in his doctor's
London surgery. The doctor looks
over to the flask on the left —
a colour change in the specimen
would indicate diabetes.

The starkness of the exposed
torso, the dark tonalities of the
painting, and its striking
theatricality reflect the artist's
enthusiasm for the works of the
Italian mannerists, for Caravaggio,
and the Spanish painter Velasquez.

Lambert has painted himself
without sentimentality, and with
astonishing directness, in an age
when nudity was more comfortably
encompassed in mythological or
biblical scenes. This bravura
painting is one of Lambert's most
interesting. It is the artist at his
flamboyant best, yet his studied
vulnerability gives us an insight
into a particularly Edwardian kind
of masculine introspection.

E. Phillips Fox 1865–1915
The green parasol c.1912
oil on canvas
117.0 x 89.5 cm

Melbourne-born Emanuel Phillips Fox was a student at the National Gallery of Victoria School before travelling to Paris in 1887, where he studied at the Académie Julian. He stayed in Paris for five years, exhibiting there in 1890. In 1892 he returned to Melbourne where he started the Melbourne Art School with Tudor St George Tucker. Fox returned to London some 10 years later and married the English artist Ethel Carrick. They lived mostly in Paris and revisited Australia only three times.

By the time *The green parasol* was painted, Fox had become well known as a fine post-Impressionist painter, with a particular talent and liking for painting figures showing the effects of light and shade. In this painting his interest in the effect of shadow cast by the green parasol on the woman's face, hands and dress is reflected in the beautiful treatment of colour, and in his title.

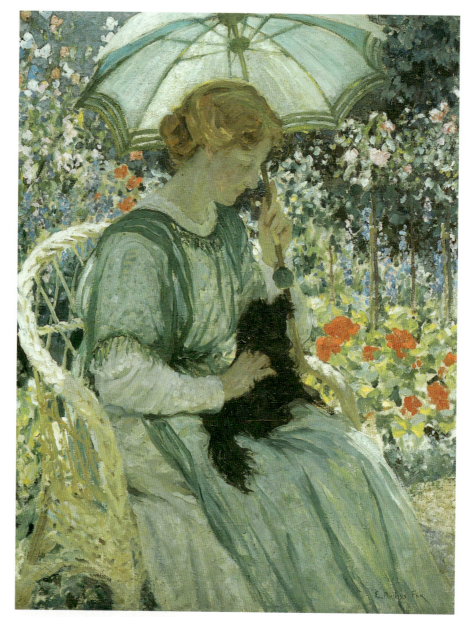

Jessie Traill 1881–1967
Good night in the gully where the white gums grow 1922
aquatint on paper
49.6 x 46.5 cm

In this boldly decorative large scale print, the white trunks of the native gums in the foreground have a majestic quality emphasised by the heavy twilight atmosphere and rich tones of the aquatint process — a technique invented to simulate the effects of watercolour. Jesse Traill had a great love of the Australian bush, and this is reflected in her work, particularly her etchings produced from the 1910s to the 1940s. She lived at Harkaway on the outskirts of Melbourne (next door to the artist Arthur Boyd) where she advocated conservation of the natural environment.

Grace Cossington Smith 1892–1984
The Eastern Road, Turramurra c.1926
watercolour on paperboard
40.6 x 33.0 cm
Bequest of Mervyn Horton

Grace Cossington Smith is regarded as one of the most important of the group of consciously 'modern' painters working in Sydney during the first decades of the 20th century. She lived in the northern Sydney suburb of Turramurra and found the subject-matter for many pictures around her home and neighbourhood. Although drawing was central to her artistic practice, Cossington Smith produced relatively few finished watercolours compared with her extensive outputs of oil paintings. During her lifetime she filled numerous sketchbooks and produced hundreds of drawings, often carefully planning a composition and establishing colour schemes in preparation for a final work.

The preliminary studies for this watercolour give us an excellent insight into the artist's working method. She wrote the words 'direction' and 'contour' across the top of the page; she reminded herself to keep the shapes of the trees 'round, full, simple masses conforming to [the] whole'. In the final work she preserved these design concepts and gave the composition an outward moving dynamism with bands of intense watercolour.

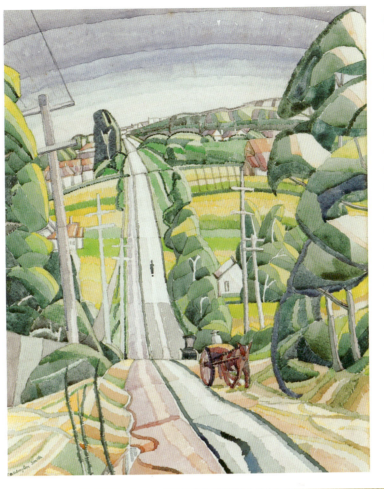

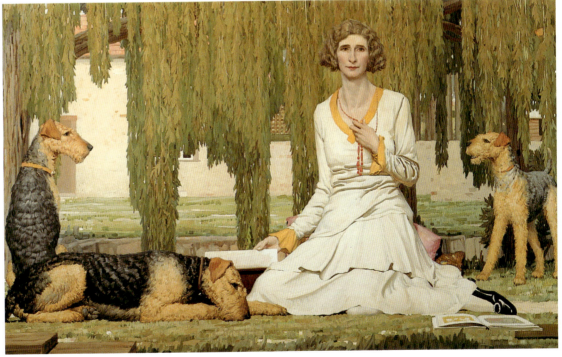

Napier Waller 1893–1972
Christian Waller with Baldur, Undine and Siren at Fairy Hills 1932
oil and tempera on canvas mounted on composition board
121.5 x 205.5 cm

This portrait of the artist's wife Christian, is Napier Waller's only completed easel painting. He is noted for his stained glass windows and glass mosaic murals which decorate many public buildings including the Australian War Memorial. Much of this work was done in close collaboration with his wife, who was also an accomplished artist. In *Christian Waller with Baldur, Undine and Siren at Fairy Hills*, Napier Waller has painted a homage to his wife, the source of his inspiration. She is seated in the garden of Fairy Hills, the Arts and Crafts house built by the Wallers at Ivanhoe, Melbourne. The Airedale dogs are named after characters in German, French and Greek mythology.

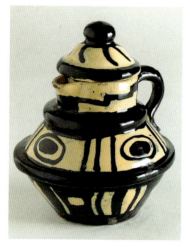

Anne Dangar 1885–1951
Coffee pot with lid c.1937
glazed earthenware
18.0 x 15.0 x 5.5 cm
Gift of Grace Buckley in memory
of Grace Crowley, 1982

The return to Australia of artists who had visited and studied art in Europe early this century, together with the arrival of the first books and reproductions of post-Impressionist art, generated amongst younger artists an interest in, and excitement about, the principles of modernism.

Anne Dangar studied painting at Julian Ashton's School in Sydney and, between 1927 and 1928, at the Académie L'hôte in Paris. She revisited Sydney for two years from 1928 but in 1930 left Australia to settle at an artists' colony in the south of France, from where she sent shipments of her pottery back to friends in Sydney. The pure, abstract decoration of her work was seen as an appropriate expression of a new age of science. Dangar's freshness and contemporary relevance lies in her fusion of modernist theory with peasant ceramic techniques, forming dramatic objects that evoke both the 19th and 20th centuries.

Max Dupain 1911–1992
Sunbaker 1937
gelatin silver photograph,
printed c.1975
37.7 x 43.2 cm
Gift of the Philip Morris Arts Grant 1983

Max Dupain embraced the style of the New Photography, an artistic movement which emerged primarily from Germany during the late 1920s and early 1930s. This movement celebrated the advances of the 20th century, and was characterised by a radically different way of framing the image. The influence of the New Photography is highlighted by the use of close-up, strong lighting, and the unusual viewpoint of Dupain's photograph, which becomes, to a certain extent, an investigation of the abstract beauty of pure form.

The sensuality of the sunbaker's flesh is emphasised by the play of light on his glistening body. One of Australia's most iconic images, *Sunbaker* has come to epitomise for many a quintessentially Australian experience.

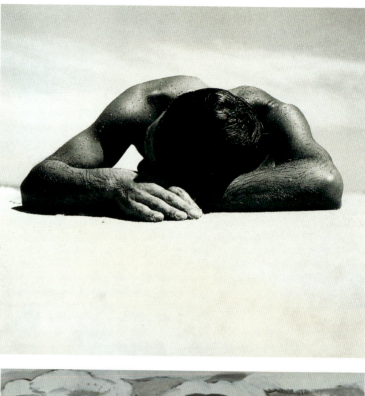

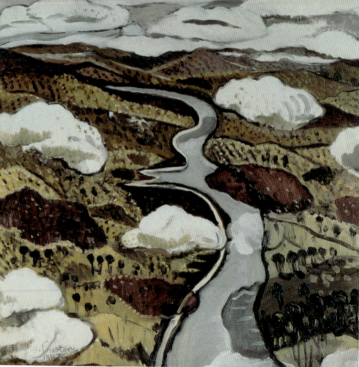

Margaret Preston 1875–1963
Flying over the Shoalhaven River 1942
oil on canvas
50.6 x 50.6 cm

Margaret Preston was an early and passionate advocate of a national art based on Australian indigenous art. *Flying over the*

Shoalhaven River is one of her best landscape paintings. In this work the artist has combined a strikingly modernist composition with the colours and conventions of Aboriginal art and Javanese fabrics, influences which Preston had incorporated in her art since the 1920s.

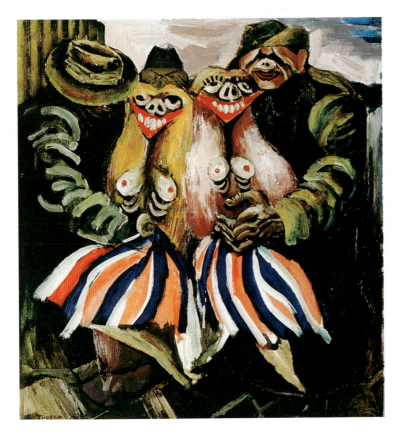

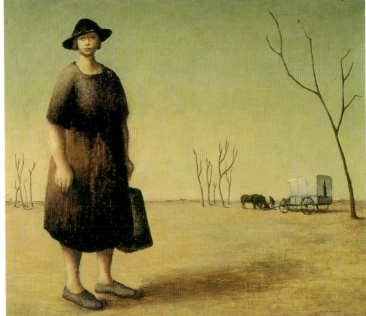

Albert Tucker b.1914
Victory girls 1943
oil on cardboard
64.6 x 58.7 cm

As a young artist in the late 1930s and early 1940s, Albert Tucker was greatly disturbed by what he perceived as the ills of the society in which he lived. His works from this time reflect his self-professed Puritanical horror at lax morality and primitive sexuality, typified for him by 'good time' girls with servicemen, and his trepidation at the eerie and vaguely threatening ambience of the blacked-out city in wartime. Behind these surface images lay his deep concern for the horrors of the war and social injustices.

Tucker's *Victory girls* are deliberately ugly figures decked out in patriotically striped skirts. Although doll-like, they are still predators, and their soldier companions are at the same time aggressors and victims. Much of the intense power of the painting derives from its crude colour and powerful brushstrokes.

Russell Drysdale 1912–1981
The drover's wife c.1945
oil on canvas
51.5 x 61.5 cm
A gift to the people of Australia by
Mr and Mrs Benno Schmidt of New York
and Esperance, Western Australia

In 1944 the *Sydney Morning Herald* commissioned Russell Drysdale to travel into far western New South Wales and record the effects of the particularly severe drought in the region. *The drover's wife*, painted almost a year after Drysdale's visit, is less illustrative of the drought than symbolic of the plight and resilience of country people facing hard times.

In the long time he took to paint them, Drysdale's subjects were transformed from quickly worked fluid ink drawings of everyday people to paintings about survival, inner strength and the dignity of labour. The direct gaze and solid stance of this young woman reveal a calm acceptance of the hard and lonely life she must endure as the wife of a drover. The landscape is non-specific, although she is having to walk for water, and the drover is barely present. Drysdale's interest is in the woman's particular strength and the power of painting to convey this.

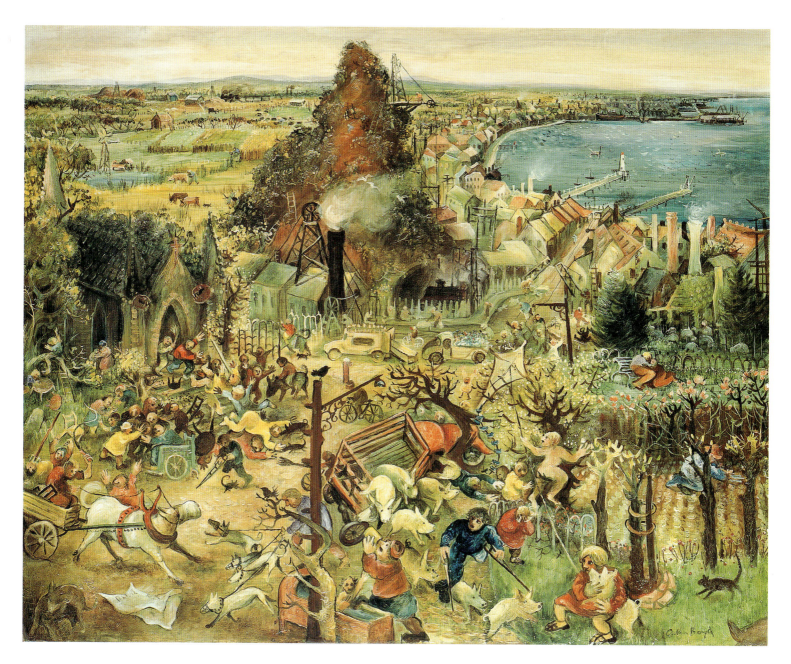

Arthur Boyd b.1920
The mining town c.1946–47
oil and tempera on composition
board
87.4 x 109.2 cm
Reproduced with permission
of Bundanon Trust

The mining town is one of a series
of postwar paintings of biblical
subjects Arthur Boyd made at Open
Country, the Boyd's family home
at Murrumbeena on the eastern
outskirts of Melbourne. Subtitled
'Casting the money lenders from the
temple', *The mining town* evokes the
universal imagery of the Bible which
Boyd's paternal grandmother, the
artist Emma Minnie Boyd, had read
to him as a child, and reflects the
artist's more particular private
imagery.

 The mining town was inspired
by the Flemish painter Pieter
Bruegel's biblical painting

Tower of Babel (1563), which Boyd
had seen in reproduction at the
Melbourne Library. Like Bruegel,
Boyd places biblical events within
a contemporary landscape of human
activity. Christ's castigation of the
money lenders and the great fiery
tower of belching chimneys and
flaming trees are set in Melbourne's
semi-rural bayside suburbs.
The allegorical and yet humane
details of entwined lovers, a funeral
procession, squealing pigs and
hobbling cripples counterpoint
vice and virtue, compassion and
cruelty, hope and despair.

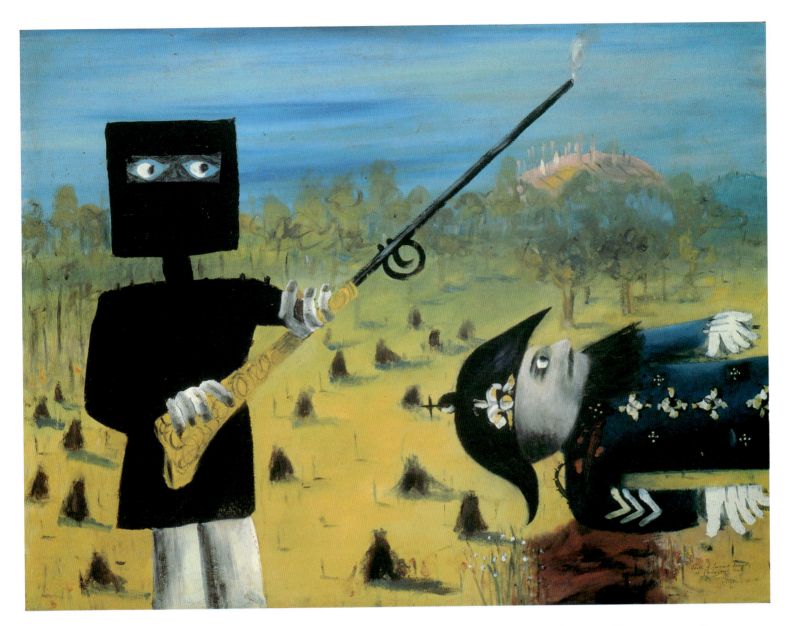

Sidney Nolan 1917–1992
*Death of Sergeant Kennedy
at Stringybark Creek* 1946
ripolin on composition board
91.0 x 121.7 cm

Although Sidney Nolan made over 45 Ned Kelly paintings between 1945 and 1947, the artist's selection of 27 for the first showing of *The 'Kelly' Paintings of Sidney Nolan 1946–47* in Melbourne in 1948 remains one of the canonic Kelly series. All but one of these paintings (*First-class marksman*) is in the collection of the National Gallery.

Death of Sergeant Kennedy at Stringybark Creek illustrates a major incident in the Kelly saga when the Kelly gang ambushed a police camp, eventually killing three of the four police officers who were in pursuit of them.

The image is a violent one: the events at Stringybark Creek and later, at Glenrowan, were tragic and fateful for all the protagonists. Although the series now looks more lyrical, it is important to remember that it was painted immediately after the Second World War, and embodies ideas about authority and sanctioned violence. The artist's fascination with the figure of Ned Kelly derived partly from the outlaw's ambiguous place in Australian cultural history. Around the figure of Kelly, Nolan worked ideas about personal responsibility, authority, violence and justice.

These are extraordinary paintings, apparently simple, but in fact remarkably complex and powerful evocations of the relationship between popular narrative and the Australian landscape.

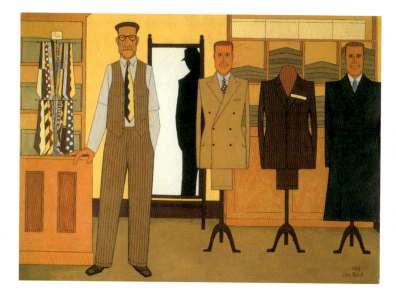

John Brack b.1920
Men's wear 1953
oil on canvas
81.0 x 114.0 cm

The setting of *Men's wear* is an old fashioned Melbourne tailor's premises. The elderly, dour salesman, smartly dressed and sporting one of the garish ties he offers for sale, is lined up with a row of young, equally well-dressed tailor's dummies.

Like many of John Brack's paintings of the time, *Men's wear* has a slightly sinister tone: here the artist (included in the scene as a silhouette in the shop mirror) comments upon the artificiality of both fashion and the painted portrait.

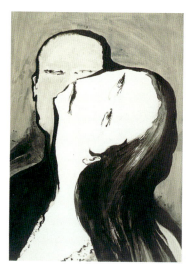

Joy Hester 1920–1960
Drawing from the love series 1955
watercolour, brush and ink on paper
75.3 x 55.5 cm

Drawing in brush and ink was Joy Hester's chosen medium. In her art she confronted life with joy and anguish. Brush and ink gave her the directness of expression and the immediacy of experience central to her approach.

Love was one of the constant themes of Hester's art and it reached its fullest expression in two series of drawings which she made in 1949 and 1955–56. In the first series Hester symbolised love through the mingling of the two lovers' faces. In the second series the drawings are still carried by the extraordinarily expressive power of the lovers' heads, but they no longer intermingle; they are separated by heavy lines. In these drawings the faces of the women are more clearly articulated than the men, whose visages are obscured and cast into the background.

The artist represents the experience of the woman as lover as one of aching vulnerability, her head thrown back, her face and heart open before us.

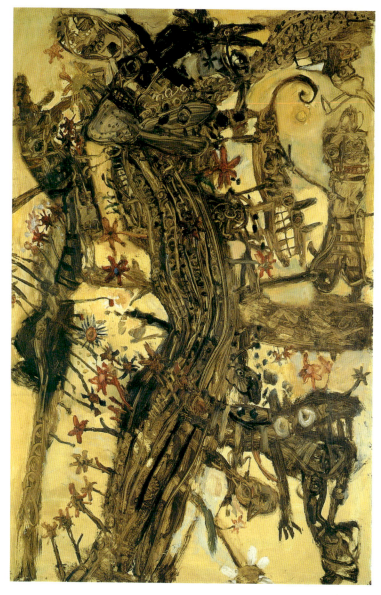

John Olsen b.1928
Spring in the you beaut country 1961
oil on composition board
183.0 x 122.0 cm
Gift of Rudy and Ruth Komon

John Olsen studied at the Julian Ashton Art School under John Passmore before going to Europe in 1956 to study painting in Spain and printmaking in Paris. His personal linear style derives in part from abstract expressionism and is strongly evocative of Asian calligraphy; his subjects are drawn from his extensive travels.

Spring in the you beaut country is a synthesis of the landscape's many forms, the geological, the microscopic, the dry and the tangled. It is as if Olsen is painting his private journey through the country, celebrating the richness and vitality of nature.

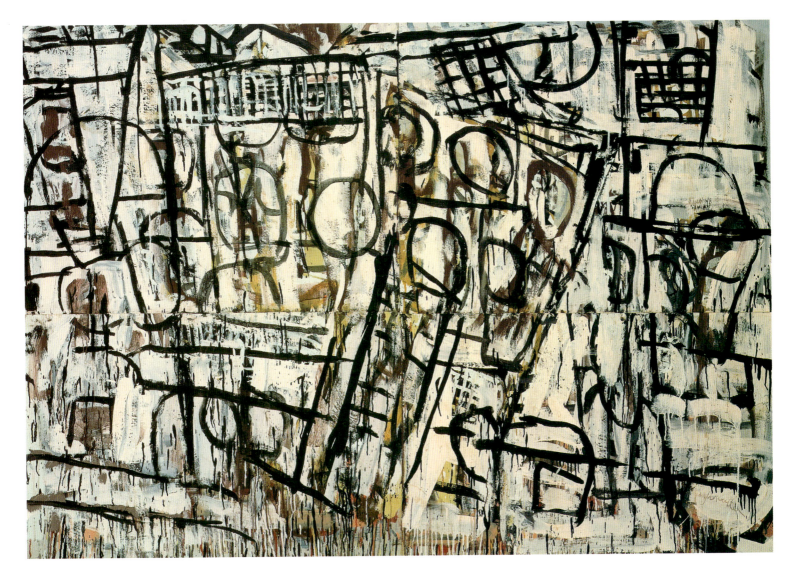

Ian Fairweather 1891–1974
House by the sea 1967
synthetic polymer paint and gouache
on cardboard on composition board
131.3 x 193.3 cm
© Ian Fairweather, 1967/DACS. Reproduced
by permission of VI$COPY Ltd, Sydney 1997

House by the sea is Ian Fairweather's last great painting, and recalls the coastal city of Shanghai where he lived from 1929 to 1932. Fairweather had fond memories living there in a room overlooking crowded Soochow Creek. The painting recalls this time through layer upon layer of paint, ending with a fiercely brushed image of black lines, like a crude ideogram of the house in its tidal setting.

The painting is composed of four joined panels that have been worked separately and then together — a technique Fairweather developed to allow his paintings 'to grow by themselves'. His method of letting a painting evolve reflected his manner of expressing inner conflict:
'In painting I am faced with a problem which I must solve. The work can only be completed when I have found the right answer'.

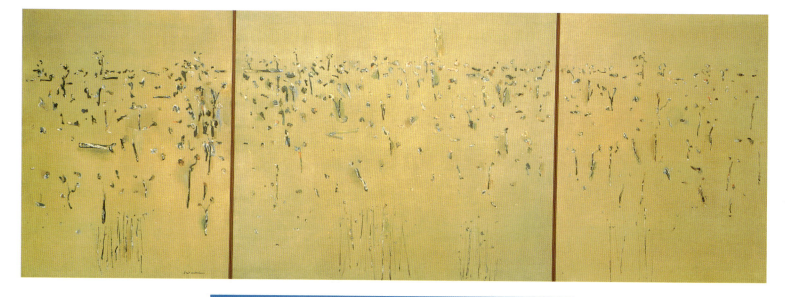

Fred Williams 1927–1982
Lysterfield triptych 1967–68
oil on canvas
152.5 x 427.5 cm
Reproduced with copyright permission

In 1963 Fred Williams and his family moved from Melbourne to Upwey near the Dandenong Ranges. Here his formalised slices of the landscape, first around Upwey and then in the nearby Lysterfield countryside, took on a sense of space and grandeur. Williams's obsession was to translate small, intensely observed but essentially abstract, painterly marks into a grand synthesis of the landscape. Spurred on by the knowledge that he was breaking new ground, he found a way of conjuring up the Australian landscape in a type of painted handwriting where every mark has its place.

This austere and reduced painterly language reaches a high point in *Lysterfield triptych*. It was a painting that Williams struggled for over a year to complete. The horizon line of the conventional landscape view has been all but abandoned in favour of an evocation of the land, both detailed and monumental, dry and lush.

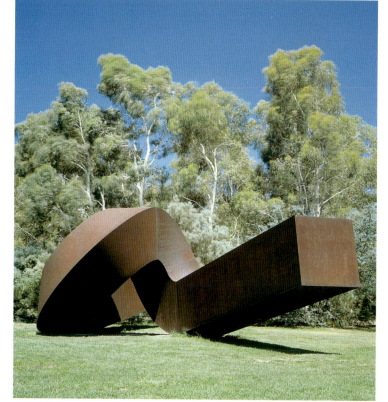

Clement Meadmore b.1929
Virginia 1970–73
weathered steel
365.0 x 1402.0 x 609.0 cm
Courtesy of Robin Gibson Gallery, Sydney

Clement Meadmore delights in the processes of surface accretion and the power of abstract symbolism. His treatment of sculptural form, at times brutally monumental, always emphasises movement, balance and an almost miraculous transformation of weight into levity. In the case of *Virginia*, over 8000 kilograms of steel appears to defy gravity with its tilted ends floating clear of the grass. The massive steel form seems to have been twisted by a giant hand. The titles of this sculpture may have several associations: it is the name of Meadmore's wife, a state in America, and the title of a jazz tune — the rhythms of which may have inspired the sweeping curves and sudden stops of rusting steel.

Meadmore was one of the first artists in Australia to seriously explore the sculptural possibilities of steel and other pre-fabricated materials. An engineer and designer, he was attracted to steel for its intrinsic qualities of strength and rigidity, allowing large volumes and planes to be drawn together by his welding torch. *Virginia* is made from an experimental brand of steel called Cor-ten which was designed to rust to a certain depth, like a soft skin around a skeleton.

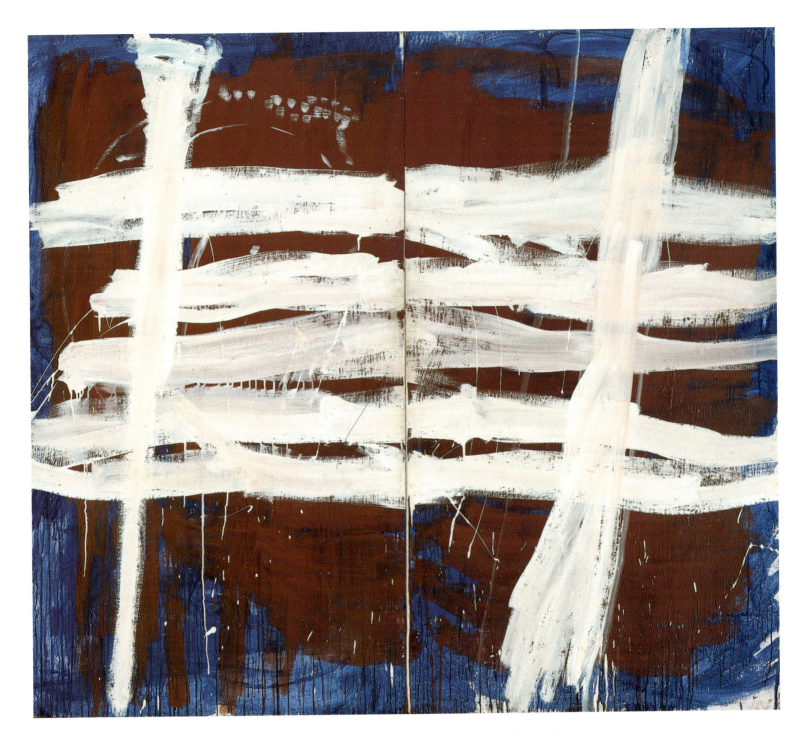

Tony Tuckson 1921–1973
White over red on blue 1971
synthetic polymer paint on
composition board
213.4 x 244.0 cm
© Tony Tuckson, 1971/ Reproduced by
permission of VI$COPY Ltd, Sydney 1997

For most of his adult life, and through choice, Tony Tuckson's role as deputy director of the Art Gallery of New South Wales (1957–73) meant that his work as an abstract expressionist artist remained largely a private preoccupation. Consequently he was free to paint purely for himself, to concentrate upon the act of painting and to avoid the need to paint something that other people could 'understand'.

The artist James Gleeson, when writing about Tuckson's second one-man show shortly before the artist's death in 1973, said: 'What he is on about is the act of painting. His pictures are about what it feels like to paint a picture — and as Tuckson feels it, a large part of it is agony ... The viewer who takes the risk of opening himself to these works will be rewarded by a rare glimpse of the emotional costs of creativity'.

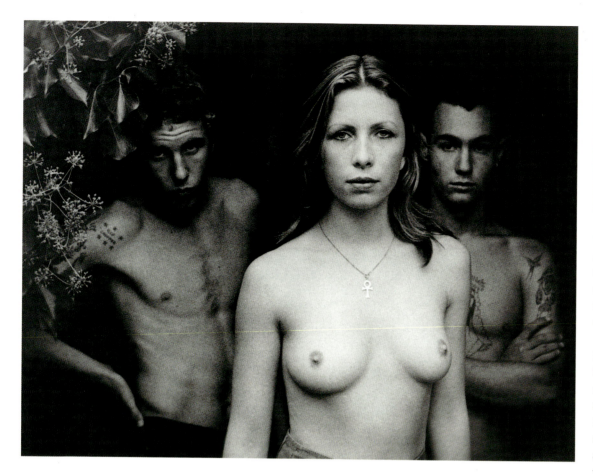

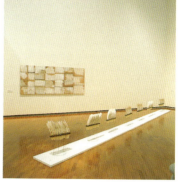

Rosalie Gascoigne b.1917
Feathered fence 1979
white swan feathers, galvanised wire,
synthetic polymer paint on wood
65.0 x 750.0 x 45.0 cm
Gift of the artist 1994

Carol Jerrems 1949–1980
Vale Street 1975
gelatin silver photograph
20.2 x 30.3 cm
Gift of the Philip Morris Arts Grant

Embodying the ethos of the Australian counterculture of the 1970s, Carol Jerrems's work is based on the consent of her subjects, enabling a sincere, intimate and candid portrait. The young woman in the foreground personifies the new contemporary woman: bold, assertive and beautiful; the feminist necklace against her naked torso proudly displays her politics. By contrast, the tattooed young men in shadow symbolise male potency; they are both bodyguards and potential aggressors. The photographer's presence is declared by the eye contact of the trio, just as their gaze includes us as viewers.

While many viewers assume this photograph represents the 'free love' ethos of the 1970s, its position in Jerrems's largely documentary body of work is complex, as the photograph was posed and is not reportage.

In her art Rosalie Gascoigne uses found objects, both natural and man-made. Like many of her manipulations of natural materials, *Feathered fence* appears deceptively simple, but the work combines actual complexity of construction with a breathtaking evocation of flight and air, as well as the intervention of human presence in the landscape. Gascoigne's work is always a response to her own understanding of the landscape, and her use of materials reflects the associative power she finds between things both natural and constructed. *Feathered fence* is lyrical and rigorous, inviting us to enter a world of landscape art which is both material and metaphorical, where art is ultimately visual poetry.

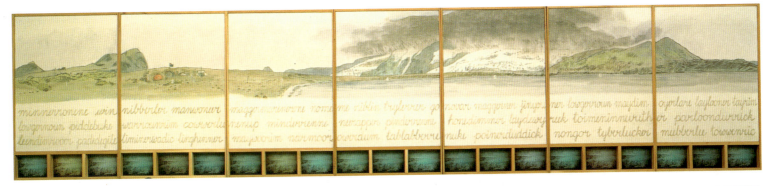

Bea Maddock b.1934
We live in the meanings we are able to discern 1987
pigment wash, charcoal, encaustic on canvas and cibachrome photograph within wooden framework
115.2 x 527.1 cm
Gift from the ANZ group

Bea Maddock visited Antarctica in January and February of 1987 at the invitation of the Artists in Antarctica Program. *We live in the meanings we are able to discern* captures the austere, untrammelled beauty of Heard Island and the sense of isolation felt by those who visit. This large multi-panelled panorama is based upon drawings made in a small sketchbook by the artist while seated on the beach at Heard Island. The cloud shrouded mountain is Big Ben, the tallest mountain on Australian territory (Mount Kosciuszko is the highest on the Australian mainland). The cost of human intervention in this most pristine landscape is reinforced by the text of Aboriginal place names from south-east Tasmania which run across the work.

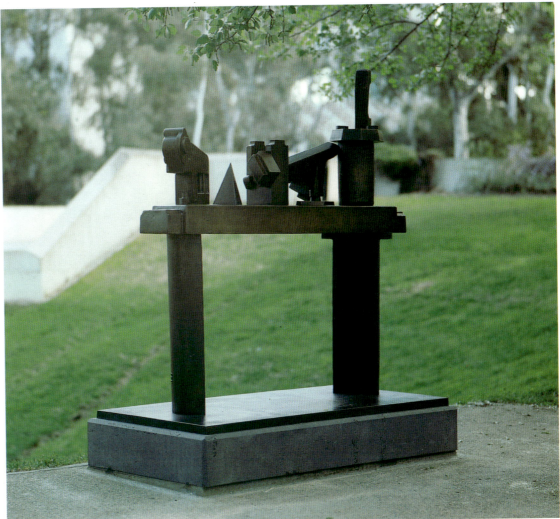

Robert Klippel b.1920
Number 751 1989
cast and patinated bronze
147.0 x 157.5 x 80.5 cm
In memory of Michael Lloyd, purchased with the assistance of his friends and colleagues

Robert Klippel has an unrivalled sensitivity for the sculptural possibilities of sometimes unlikely materials. Since 1944 he has balanced the rusted insides of old typewriters or carved sandstone to combine man and machine, or collaged old magazines into documents on the endless minutia of life. In *Number 751*, Klippel's carefully selected and placed forms are arranged into a study of brooding monumentality, like a mantlepiece of odd unusable machines. This bronze, cast in 1997, faithfully reproduces the sombre character of the original and is permanently installed in the National Gallery sculpture garden.

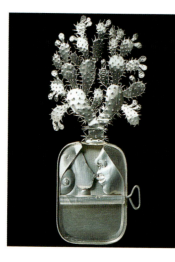

Fiona Hall b.1953
Paradisus Terrestris 1989–90
23 sculptures from the series
aluminium and tin
each 24.5 x 11.0 x 1.5 cm

In *Paradisus Terrestris* the Garden of Eden is represented as a botanical garden, where nature is classified, arranged and labelled. Fiona Hall's title is based on the first comprehensive British gardening book, John Parkinson's florilegium, *Paradisus in Sole. Paradisus Terrestris* (1629).

The framework of Hall's earthly paradise is a series of sardine tins transformed into elaborate sculptures. Lush plants are cut from the metal of the sardine tins to represent the physical aspect of the garden. The leaves and branches, like fine silver filigree, are botanically accurate and are comprised of entwined or espaliered boughs, foliage, fruit and pods. In this garden each plant is identified by its botanical name and compiled into an encyclopaedic collection of common and rare species. But the tins are also keyholes into which we have to peer to catch glimpses of interlocked human forms inside. The temptation in the Garden of Eden, discernible here as intricately formed sexual organs, hands and breasts, corresponds to the sensuous attributes of the plants above.

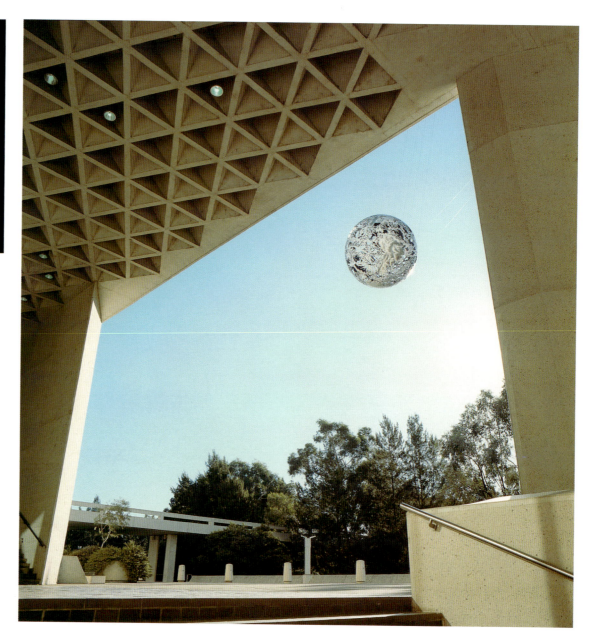

Neil Dawson b.1948
Globe 1989
laminated carbon fibre, fibreglass and polyurethane, steel
diameter 4.5 m

Globe, by New Zealand artist Neil Dawson, is not like a terrestrial globe, rather the image of the earth as seen from outer space. Held in place by fine steel cables running between the National Gallery of Australia and the High Court of Australia, the sculpture is freed from the confines of gallery space and becomes accessible to everyone. Originally modelled from the first NASA photographs taken from space in the 1960s, *Globe* is constructed from yacht building materials, polyurethane and carbon fibre, and weighs only 76 kilograms. Visually held together by the clouds, it is physically held together by the linking of a number of hexagons, like a huge soccer ball.

With his ability to magically float unexpected illusionary images within architectural spaces, Neil Dawson has gained renown for his suspended lightweight sculptures in cities around Australia and Asia.

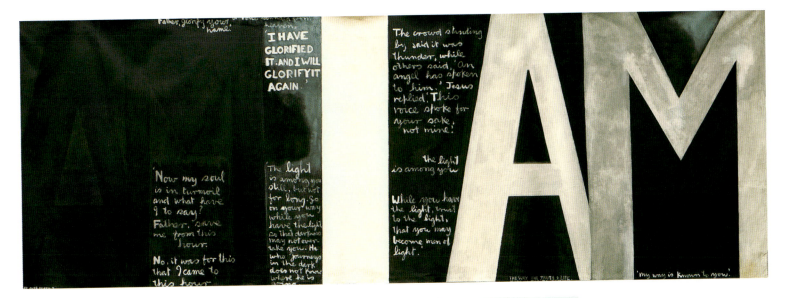

Colin McCahon 1919–1987
Victory over death 2 1970
synthetic polymer paint on canvas
207.5 x 597.7 cm
A gift of the New Zealand government 1978

Victory over death 2 takes its inspiration in equal measures from the artist's heart, symbolic passages of the *New English Bible* (principally John's Gospel 11) and the landscape of New Zealand. It stands as Colin McCahon's great masterpiece — given to the people of Australia by the New Zealand government.

Victory over death 2 writes large the proclamation of divine being, 'I AM'. McCahon combines this monumental statement with a grand rudimentary landscape — the wild side of New Zealand: 'I saw something logical, orderly and beautiful belonging to the land and not yet to its people. Not yet understood or communicated, not even really yet invented. My work has largely been to communicate this vision and to invent the way to see it'.

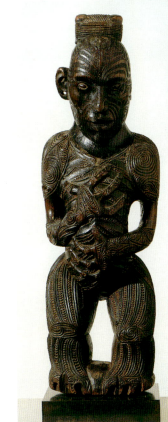

possibly Raharuhi Rukupo d.1873
Maori people, Gisborne area, North Island, New Zealand
Ancestor figure (poutokomanawa) from a housepost c.1840
wood, pigment
79.7 x 26.5 x 20.2 cm

This figure of a chief, now free-standing, was originally an ancestral image carved at the base of a pole supporting the roof-beam of a meeting house. Symbolically, the chief is supporting the backbone of the first ancestor whose body the house represents.

It is clearly from the Gisborne area on the east coast of the North Island. Its naturalism is typical of the mid 19th century, and in style it probably represents the work of Raharuhi Rukupo. Raharuhi was a celebrated master of the period and leader of the Gisborne or Turanga school of carving. He was in fact the innovator who developed the decorated meeting house to its zenith.

Raharuhi built the famous Te Hau-ki-Turanga meeting house in the Te Papa Tongarewa National Museum of New Zealand.

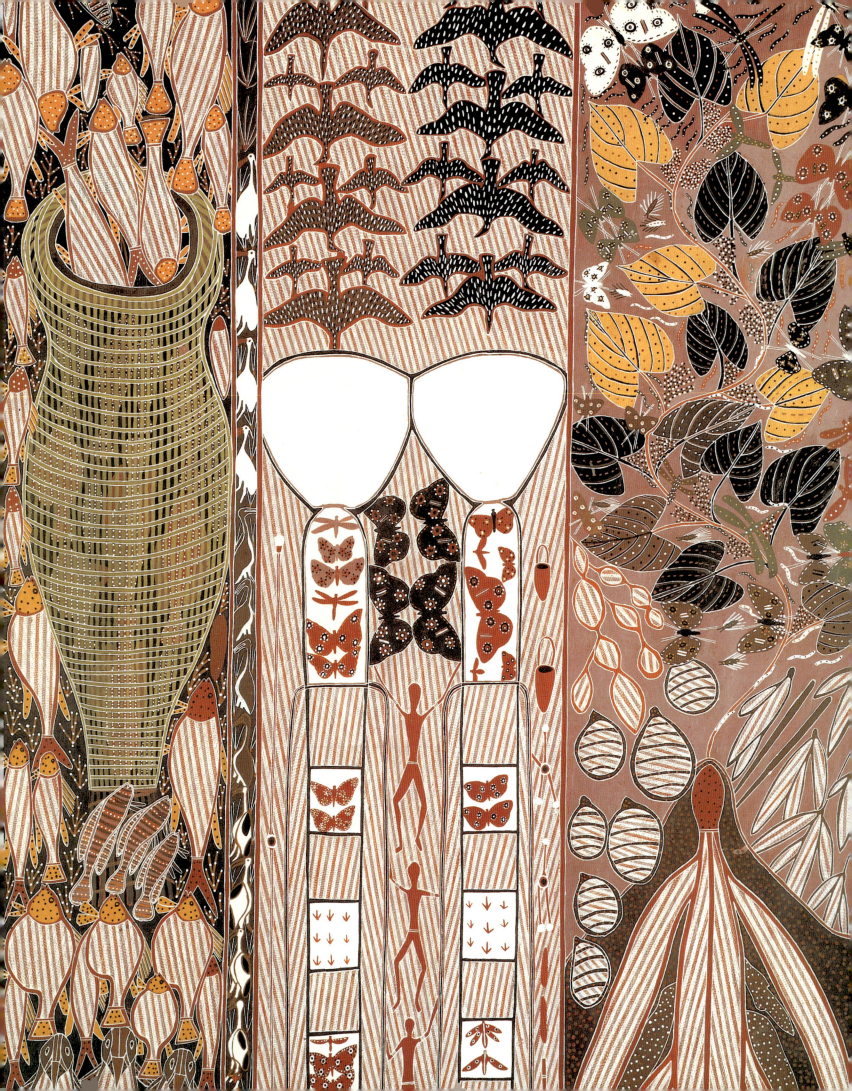

ABORIGINAL AND TORRES STRAIT ISLANDER ART

The art of indigenous Australia is the oldest continuing tradition of art in the world and one of the two major art traditions operating within Australia today. The National Gallery collects art made by Aboriginal and Torres Strait Islander Australians to document and represent the continuing and evolving traditions which reflect the diversity of indigenous experiences over time and from each part of the continent.

The collection includes significant works from all of the major art regions of indigenous Australia. These include the Top End — Arnhem Land in the Northern Territory and its environs — from which come bark paintings, weavings and sculptures; the central and western deserts, whose artists are known for both acrylic paintings on canvas, and batiks; the Kimberley region in north western Australia, which produces paintings on canvas and bark as well as a range of ritual objects, from incised pearl shells to decorated dance wands; the Torres Strait Islands, well known for sculptures, dance machines and headdresses; and urban and rural areas, where artists work in a wide range of media including new technologies of computer generated images, neon, video and film.

Art is central to Aboriginal life. It expresses individual and group identity, and the relationships between people and the land. It also comments on the contemporary realities of its creators. Whether it is made for political, social, utilitarian or didactic purposes, art is inherently connected to the spiritual domain. The spiritual life of Aboriginal people centres on the Dreaming, an English term used by Aboriginal and non-Aboriginal people alike to describe the spiritual, natural and moral order of the universe. The Dreaming focuses on the activities and epic deeds of the supernatural beings and creator ancestors who, in both human and non-human form, travelled across the unshaped world creating everything in it and laying down the laws of social and religious behaviour. The supernatural and ancestral beings left their spiritual forces in the earth and these continue to sustain generation after generation of Aboriginal people. The Dreaming provides the great themes of Aboriginal art.

Each tradition of Aboriginal art represents a distinct visual language, with its own vocabulary of icons and symbols which possess a wealth of meanings and interpretations. In Arnhem Land, for example, artists use figurative images, geometric designs and clan patterns, whereas in the desert a range of icons such as concentric circles, meandering lines, U-shapes and fields of dots possesses a wealth of meanings.

Selections from the Gallery's collection of Aboriginal and Torres Strait Islander Art are displayed in the Loti and Victor Smorgon Gallery at the entrance of the building. The works in this gallery are changed regularly for reasons of conservation and to give the regular visitor a view of the many riches of the collection. In addition, Aboriginal and Islander art is also displayed in the broader Australian and international contexts in other rooms of the Gallery. A permanent feature of the display is *The Aboriginal Memorial* (1987–88), an installation of 200 painted hollow log coffins by the artists of Ramingining in Arnhem Land. The *Memorial*, a collaborative work involving 43 artists, is dedicated to all Aboriginal people who lost their lives defending their country and for whom no funeral ceremonies had taken place. As visitors walk through its forest of 'painted tree trunks' they are in fact passing symbolic coffins. Moreover the artists who conceived this work also see it as an entreaty for a more just and equitable society.

Over the years the collection has kept track of developments in the production of art across indigenous Australia. The majority of holdings date from the mid-1970s to the present with the first major purchases being eight series of bark paintings by Bill Namyiangwa (c.1925–1968) and Thomas Nandjiwarra (1926–1989) from Groote Eylandt in the 1950s, and a collection of 139 bark paintings by West Arnhem Land artist, Yirawala (1903–1976). Other highlights include the *Krill Krill* 1984 series of paintings by Rover Thomas and Paddy Jaminji from the eastern Kimberley, Jack Wunuwun's *Barnumbirr the Morning Star* (1987), paintings by George Milpurrurru, *The Alhalkere suite* (1993) by Emily Kame Kngwarreye, Robert Campbell Jnr's historic canvas *Aboriginal Embassy* (1986) and a series of articulated dance machines and headdresses by Ken Thaiday from the Torres Strait. The collection of art from the deserts features several major individual works from the early 1970s to the present including a series of 14 canvases by the Warlpiri artists of Yuendumu which describe the creation of the ancestral landscape along kinship lines.

Other major works include: Yvonne Koolmatrie's *Bi-plane* (1994), David Malangi's *Dhamala story* (1993), Clifford Possum Tjapaltjarri's *Yinyalingi Honey Ant Dreaming* (1984), and Mick Namarari Tjapaltjarri's *Sunrise chasing away the night* (1977–78).

The Gallery's program of exhibitions of indigenous art has been wide-ranging: from the large survey of 500 works in 'Aboriginal Art: The Continuing Tradition' in 1989, to the recent presentation of a single tradition of art-making by successive generations in 'The Painters of the Wagilag Sisters Story: 1937–1997'. Within that time exhibitions have also focused on regional styles — for example a 1987 exhibition of bark paintings from Arnhem Land and a 1996 exhibition of paintings from the desert community of Papunya — and on the work of individual artists, such as George Milpurrurru and Rover Thomas. In 1996 'The Eye of the Storm: Eight Contemporary Australian Indigenous Artists', which opened in New Delhi, celebrated the contemporary nature and relevance of indigenous art.

The flourishing interest in Aboriginal and Islander art has created new opportunities for artists. While the imperatives to produce art for traditional purposes continue, the expanded environment in which indigenous art now operates has created further reasons for artists to continue to express the values of their culture to the wider community. Their work is a testament to the enduring and dynamic nature of indigenous culture. The National Gallery's role is to represent these artistic traditions and to tell the story of Australia's indigenous art, from historical times to the present.

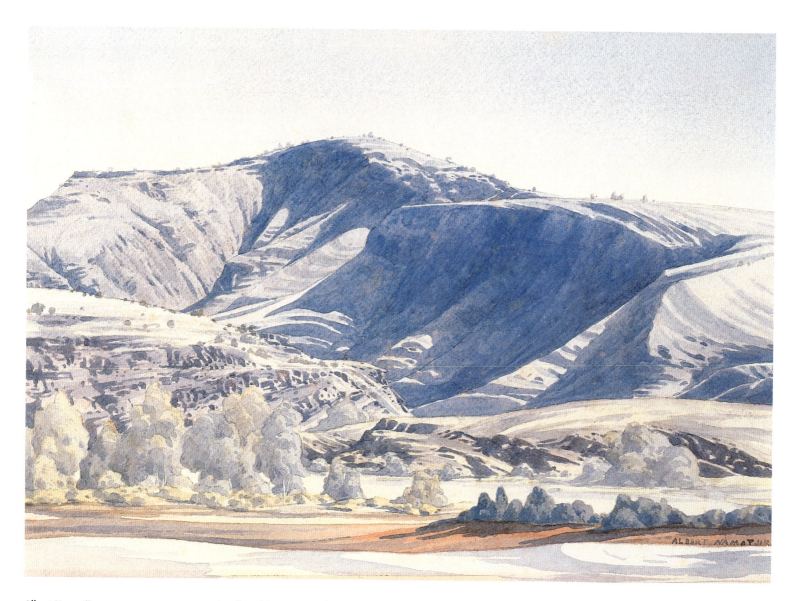

Albert Namatjira 1902–1959
Arrernte people
Mt. Hermannsburg, Central Australia
c.1950
watercolour, pencil on paper
37.0 x 54.0 cm
© Legend Press

In the 1930s Rex Batterbee, a non-Aboriginal artist, introduced the technique of watercolour landscape painting in the European vein to Aboriginal people at the Lutheran Mission at Hermannsburg, west of Alice Springs. It was taken up by Albert Namatjira, who became Australia's first popularly known Aboriginal artist. The so-called Hermannsburg school of painting developed into a 'popularist' art in the 1950s and 60s whereby the vibrant landscape watercolours from Australia's 'centre' dominated public buildings and were found in suburban homes where commercially available prints hung over the mantelpiece.

The school of painting which developed among the Arrernte at Hermannsburg continues to produce watercolours today.

For all his success, Namatjira's achievements were dismissed by art commentators until recent re-assessment of his work in the modern era of Aboriginal art. Namatjira is now seen to have reworked the models of European pictorial perspective to express his personal vision. His subjects were not chosen for their ostensible beauty in European terms, as had been thought, but were ancestral landscapes through which he expressed his relationship to the country to which he was spiritually bound. Namatjira's images are of the land created in the Dreaming, untamed by the requirements of the pastoral industry and by other evidence of European settlement.

Namatjira held his first solo exhibition in 1938, but despite his fame he died disillusioned by white society. In an era of official attempts to assimilate Aboriginal people into the mainstream of society, Namatjira's mastery of European techniques was interpreted as evidence for the potential success of this policy. Nonetheless, Namatjira had made a major contribution to changing negative public perceptions of Aboriginal people, and laid the groundwork for the acceptance of more recent developments in Aboriginal art, particularly in the desert where the Papunya school of painting emerged 12 years after Namatjira's death.

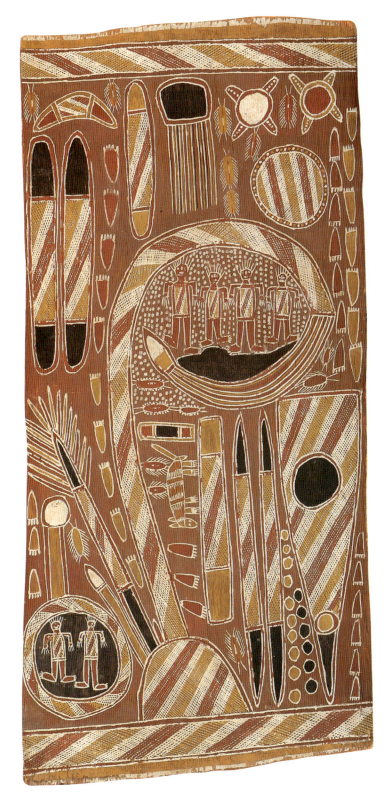

Dawidi 1921–1970
Liyagalawumirr people
Wagilag Creation Story 1963
natural pigments on eucalyptus bark
110.0 x 50.0 cm
© Courtesy of Aboriginal Artists Agency,
Sydney

The ancient story of the Wagilag Sisters heralds the arrival of the first monsoon season and the flooding of the earth. More importantly, the story documents the foundation of the laws of social and ritual behaviour, particularly relating to the rules of marriage.

The narrative relates the adventures of two Sisters who flee their home in South Eastern Arnhem Land. The older Sister has a child and the younger Sister is pregnant. They head towards the stone quarries of Ngilipidji in the land of the Wagilag clan, from where the Sisters get their name. Further north, they camp at the waterhole at Mirarrmina, disturbing the home of Wititj the Olive Python, one of the most powerful ancestral figures. In order to appease the ancestor who is angered by their presence, the two Sisters create the songs, dances and rituals that are performed to this day by the peoples of Central and North Eastern Arnhem Land.

The focal image in the painting is that of the Python emerging from the waterhole at Mirarrmina to surround the Sisters and their children. The Python is in the act of swallowing them. The image forms a template, or compositional device, for many paintings related to the Wagilag story.

The footprints were made by the Sisters as they danced. Above them are the stars, the moon and the rain cloud of the first monsoon. In the lower section the Sisters' dog appears, beside a vertical hollow log. Next to the dog are the itchy caterpillars which bit the Sisters after they were regurgitated by the Python. The caterpillars make their nests at the onset of the wet season.

Wititj's waterhole appears as a semi-circle at the lower centre of the painting. To the left of Wititj is a Sand Palm (*wurrdjarra*) and a small image of a python which represents Wititj as it stood erect in the sky and informed other ancestral pythons that he had swallowed the Sisters, their children and all their possessions.

The other pythons told Wititj that he had acted wrongly in eating members of his own family and so, overcome by illness, Wititj crashed to earth. Wititj's fall is indicated by the inverted triangular shape in the lower right; this is the depression made as the Python's tail hit the ground and is now the shape of a ceremonial ground sculpture.

Mawalan Marika *c.*1908–1967
Rirratjingu people
The coming of the Macassan traders
1964
natural pigments on eucalyptus bark
95.0 x 50.0 cm
Purchased from National Gallery admission
charges 1987
© Courtesy of Aboriginal Artists Agency,
Sydney

This painting compares two
moments in the history of the
Yolngu (Aboriginal people in
Central and Eastern Arnhem
Land); the creation of the original
Yolngu clans by the Djan'kawu
ancestors at the very beginning
of time and the arrival of the
Macassan fishermen several
centuries ago.

The painting was made
in response to a question put
to Mawalan by the collector
J.A. Davidson. Davidson asked
how long the Macassans had
visited the shores of Arnhem Land.
Mawalan's artistic response
indicates that they had been
known from the ancient past;
relative to the short time
Europeans have been in Arnhem
Land, the Macassan presence
compares with that of the
ancestors.

On the right of the vertical line
dividing the composition is a
classical version of one of the
Djan'kawu Sisters giving birth
to the Dhuwa moiety people.
(The Dhuwa moiety is one of two
complementary social and
religious categories in Central and
Eastern Arnhem Land. The other
is the Yirritja.) Above the Sister
is Djanda the Goanna.

To the left of the vertical line
is a Macassan *prahu*, or ship, with
its crew on deck. One of the crew
members, painted black,
is a Yolngu person. On occasion
Aboriginal people accompanied
the Macassans back to their home
in what is now Sulawesi in
Indonesia.

The hull of the *prahu* is
depicted in profile to show
members of the crew, a goat,
a cock (a talisman to fend off evil
spirits), bags of rice, and two crew
members plying the double rudder
of the ship. The sails are not
depicted. Two canoes or boats are
depicted; one appears tied to the
stern of the boat, the other below
the two bags of rice at the front
of the hull.

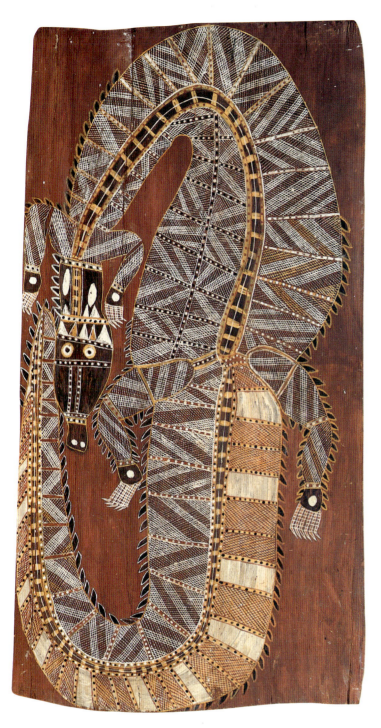

Yirawala 1903–1976
Kuninjku people
Namanjawarre, the Mardayin crocodile
c.1973
natural pigments on eucalyptus bark
115.0 x 58.5 cm
Collected by Sandra Holmes. Reproduction
courtesy of Sandra Holmes

The saltwater crocodile is an
important figure in the sacred
Mardayin ceremonies of the
Kuninjku or eastern Kunwinjku
people of western Arnhem Land.
In the Dreaming, Namanjawarre
lived in a billabong from where
he ate his way through a mountain
range to the Arafura Sea thus
creating the Liverpool River.
In this painting, the shape of
Namanjawarre suggests the curved
banks of a billabong.

Yirawala has rendered
Namanjawarre in the characteristic
West Arnhem Land style of
painting known as 'X-ray' where
the internal organs and bones are
shown. To either side of the
backbone are sections of *rarrk*,
or cross-hatched clan designs;
these are similar to designs
painted on participants' chests
in related ceremonies.

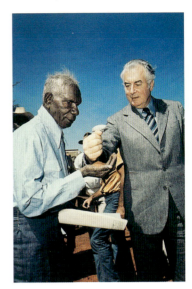

Mervyn Bishop b.1945
*Prime Minister Gough Whitlam pours
soil into the hand of traditional land
owner Vincent Lingiari, Northern
Territory* 1975
direct positive colour photograph
55.9 x 40.6 cm

In 1967, two hundred Gurindji
stockmen went on strike on the
Wave Hill (Wattie Creek) cattle
station in the Northern Territory
demanding improved living and
working conditions. The strikers
extended their demands by
declaring their rights to traditional
lands. The resulting publicity
helped to highlight the social
and economic plight of
Aboriginal people.

The photographic work
of Mervyn Bishop spans some
30 years of Australian history.
This image of the Gurindji
people's success in winning back
their traditional land entered the
nation's consciousness. The image
is made more poignant by its
focus on the red soil in the hands
of Lingiari who was by that time
almost totally blind.

Mick Namarari Tjapaltjarri b. *c.*1926
Pintupi people
Sunrise chasing away the night
1977–78
synthetic polymer paint on
composition board
40.0 x 60.0 cm
© Courtesy of Aboriginal Artists Agency,
Sydney

The painting is a depiction of the
night and its phases, and the rising
of the sun over the landscape.
The point of view seems to be
from the heavens looking down
through the stars, past the rising
sun and the night onto the
campfires burning on the great
plain below. The conventional
depiction of the landscape in
desert paintings is in plan view:
as though the viewer were looking
down from above onto the land.
Namarari takes this way of
representation to extraordinary
lengths.

The work was commissioned
by Geoffrey Bardon, who, as a
teacher at the Papunya school was
a catalyst to the acrylic painting
movement at Papunya in the
early 1970s.

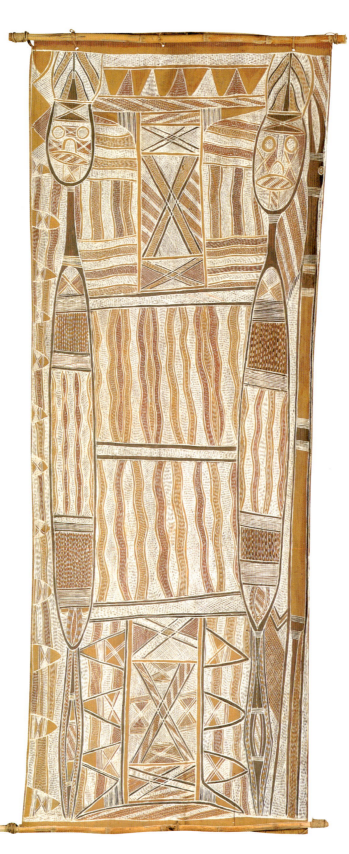

Narritjin Maymuru *c.*1922–1981
Manggalili people
Nyapililngu ancestors at Djarrakpi
*c.*1978
natural pigments on eucalyptus bark
158.0 x 60.0 cm
Purchased from National Gallery admission
charges 1986

This painting maps the creation
of the landscape at Djarrakpi
(Cape Shield) in Eastern Arnhem
Land by the ancestral women,
the Nyapililngu in Manggalili clan
country. The women performed
the first Manggalili funeral
to grieve for their dead brother,
the koel-cuckoo Guwak.

The composition of Narritjin's
painting is a map of the country
oriented from south, at the top,
to north. In the painting, the two
Nyapililngu ancestors are
constructed from the symbols
of women's life: digging sticks,
dilly bags and the crosses
indicating women's breast girdles.
The ovoid shapes at the lower
sections of the women's bodies
relate to the earth sculpture made
in the funeral ceremony. Along the
right edge of the bark, Guwak
appears elongated as a length of
the possum-fur string he collected
and which the women spun to
make a sand ridge that is now
the men's side of Djarrakpi.

The middle of the painting
depicts the lake at Djarrakpi.
The triangular shapes along the left
edge indicate women's breasts and
the sand dunes along the seaward
or women's side of the lake.
The casuarina trees that form the
tops of the women's heads are the
final resting place of Guwak. The
anvil shapes in the upper and lower
sections of the painting symbolise
the high cumulus clouds created
by the smoke from the fire the
Nyapililngu lit as they mourned
their brother.

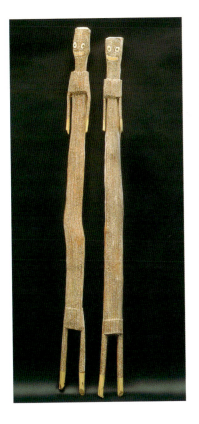

Crusoe Kuningbal 1922–1984
Kuninjku people
Mimi figures 1979
natural pigments on wood
heights 216.0 cm and 221.0 cm

These sculptures by Kuningbal demonstrate that artistic innovation occurs within the ceremonial context and how this may be adapted to the public domain. Kuningbal is credited with developing this form of wooden *mimi* spirit figure in ritual and for sale.

Sculptures similar to these are used in Mamurrng exchange ceremonies, performed to celebrate the birth of a male child, where they watch over the wrapping of carved wooden bones. These figures are related to *djorndjorn* figures, sculptures known from the 1940s, which were made of paperbark covered in bush string and used as grave markers.

In contrast to the animated paintings of *mimi* spirits found on the rock surfaces of the Arnhem Land plateau, Kuningbal's sculpted figures of *mimi* are static.

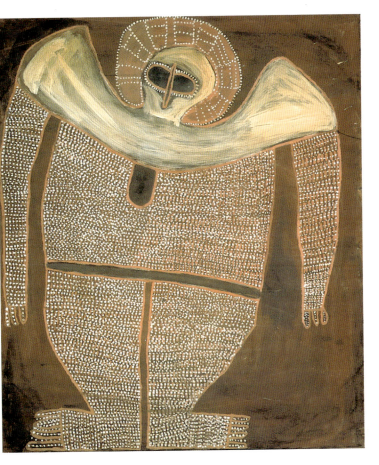

Alex Mingelmanganu d.1981
Kulari/Wunambal people
Wandjina c.1980
natural pigments and oil on canvas
159.0 x 139.5 cm

In many parts of the Kimberley in Western Australia, the Wandjina ancestral beings established the laws of social behaviour. The Wandjina are associated with the life-giving properties of water. They bring the monsoonal rains and distribute the spirits of the unborn to their eventual parents.

Images of the great creator Wandjina appear on the walls of caves and rock shelters of the Kimberley. People say that the Wandjina themselves left their images on the rock surfaces after they had completed their creative actions. In more recent times images of Wandjina have appeared painted onto sheets of bark, utilitarian objects and canvas.

To safeguard the continuation of the cycles of nature, it is the duty of the Wandjina's human descendants to conserve these images. Mingelmanganu continued the tradition in his canvases which convey the scale of the rock paintings.

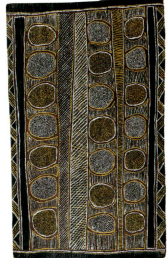

Declan Apuatimi 1930–1985
Tiwi people
Untitled 1982
natural pigments on eucalyptus bark
94.0 x 59.5 cm
© Courtesy of Aboriginal Artists Agency, Sydney

Declan Apuatimi is one of the best known artists from the Tiwi islands, situated off the coast of Darwin in the Northern Territory. He is noted especially for his many fine and innovative human figures, carved from ironwood and related to the Pukumani funeral ceremony that is unique to the islands. Apuatimi was an active participant in ceremonial life and is well known for the songs and dances he composed.

As with much Tiwi painting, the subject matter is personal to the painter and not necessarily explicable in terms of ancestral narratives. The columns of circles in the painting indicate the sun or places in the Dreamtime journey of the sun-woman. They may also indicate eggs or, more likely in Declan's case, rocks on the beach at Imilu. His Dreaming is *waranga*, or stone, and his particular Dreaming site is Imilu. Superior yellow ochre which turns red on heating is found there. Two other columns show cross-hatching similar to those painted on bodies for ceremonies.

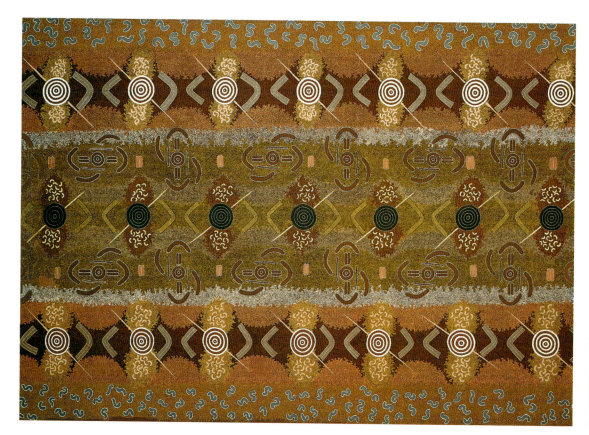

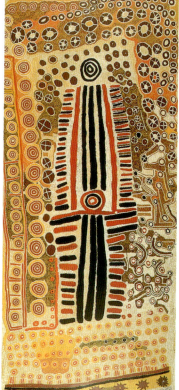

Clifford Possum Tjapaltjarri b.1933
Anmatyerre/Arrernte people
Yinyalingi (Honey Ant Dreaming)
1984
synthetic polymer paint on canvas
244.0 x 366.0 cm
Purchased from National Gallery admission
charges 1984
© Courtesy of Aboriginal Artists Agency,
Sydney

In the Dreaming, groups of Honey Ant people (Tjala) travelled the country and established important religious sites such as rock-holes and rocky outcrops. These features represent the Honey Ant ancestors themselves and mark the sites of their ancient underground chambers.

The ancestors also created ceremonies around large ground paintings: Clifford Possum's canvas depicts a site at Yinyalingi, west of Alice Springs, where the ancestors conducted a law-giving ceremony.

The top, central and bottom rows of images show ceremonial body painting designs used by women as well as depicting the women themselves: the curves represent sitting women, the diagonal bars their digging sticks and the grub-like shapes the honey ants. These alternate with rows of images depicting the ceremonial seating arrangements for men.

The two white horizontal bands indicate the mists prevalent in the area on cold winter mornings. The grubs depicted along the top and bottom of the painting are eaten by goannas which in turn provide an important source of food for people, suggesting the richness of this land.

Paddy Jupurrurla Nelson b.1919
Paddy Japaljarri Sims b.1916
Larry Jungarrayi Spencer 1912–1990
Warlpiri people
Yanjilypiri Jukurrpa (Star Dreaming)
1985 synthetic polymer paint
on canvas
372.0 x 171.4 cm
Purchased from National Gallery admission
charges 1986
Reproduced with permission of
Warlukurlangu Artists, Yuendumu,
Northern Territory

This painting is one of the first large scale canvases to emerge from the community of Yuendumu, north west of Alice Springs and home to the Warlpiri people.

The owners of this image prefer to restrict its description to the fact that the work concerns the Warlpiri fire ceremony associated with the creation of the constellations.

The collaboration of the several artists is typical of the way in which ceremonial ground paintings, on which this image is based, are made. In this case, the owner of the Dreaming is Jimmy Jungarrayi Spencer who supervised the painting but did not participate. Paddy Jupurrurla Nelson has matrilineally inherited rights to the Dreaming and was the main painter. He was assisted by Paddy Japaljarri Sims and Jimmy Jungarrayi Spencer's younger brother Larry Jungarrayi Spencer.

Robert Campbell Jnr 1944–1993
Ngaku people
Aboriginal Embassy 1986
synthetic polymer paint on canvas
88.0 x 107.3 cm
Courtesy Roslyn Oxley9 Gallery

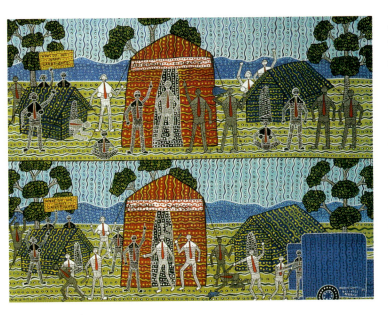

Robert Campbell Jnr wanted to present through his art the Aboriginal view of Australian history. Campbell drew his subjects from traditional life, major events such as the first landing of the British, the deforestation of the land, and social issues such as the treatment of Aborigines at the hands of the colonisers, segregation at picture theatres and whites-only swimming pools, right through to Aboriginal Land Rights and deaths in custody.

The Aboriginal Tent Embassy was set up in 1972 outside the Parliament in Canberra as a symbol that indigenous people were treated as foreigners in their own land. It became a rallying point for Aboriginal people and their supporters and a focus reminding Australians and the world of the 'special treatment' that Aboriginal people have had to endure in their own country.

Aboriginal people and their supporters involved in the establishment of the embassy went on to develop the first of the grass roots Aboriginal organisations, such as legal services, housing, education, health services, which set up throughout Australia in the early 1970s. More than 20 years on, Aboriginal people from all over Australia have continued to come to the Aboriginal Embassy in Canberra to demonstrate for improvement of social conditions for indigenous people.

As an Aboriginal man it is important for me to pass on my culture to our youth both black and white ... Our children are our future ... I want to tell my stories so we can have a better future for all Australians. Robert Campbell Jnr, 1992.

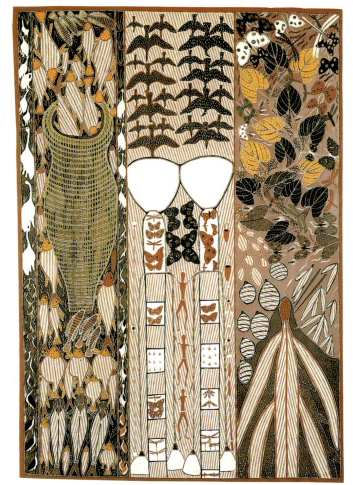

Jack Wunuwun 1930–1990
Djinang people
Barnumbirr the Morning Star 1987
natural pigments on eucalyptus bark
178.0 x 125.0 cm

Wunuwun's clan, the Gangarl, is one of the custodians of the ceremony of Barnumbirr the Morning Star. In this painting Wunuwun connects the cycle of life and death and the journey of the soul to the land of the dead with the monsoonal season in Arnhem Land.

In the central panel, the onset of the monsoonal rains which fertilise the earth is suggested by a flock of ibis. Below this, the ceremonial Morning Star poles are symbolic of procreation. The poles, with two *bardai* or feathered strings attached, are crowned by large feathered tassels, while figures dance between them. Beside the poles, Wunuwun has depicted ceremonial objects including feathered armbands, dilly bags and clapsticks.

The poles are decorated with images of butterflies and dragonflies. Later in the wet season, these insects will swarm around the flowering vines of the yam plant. Wunuwun is suggesting the connection between the Morning Star poles and the yam plant seen in the right-hand panel.

The latter image is set in Mayaltha, the second half of the wet season, when the yam plant, *bartji*, is in blossom. Its tubers and flowering vine are symbolic of the Morning Star pole — the strings and feathered tassels represent morning stars. Here, Wunuwun has depicted young and old yams below the surface of the earth; the cross-hatched yam tubers represent new growth, while the spotted ones are old yams.

Butterflies (*bonba*) and dragonflies (*murgurrwa*) are feeding off the flowers of the yam. Clusters of round yams and long yams are painted on a smaller scale.

At the end of the wet season, in Mirdawarr, vegetable foods are ready to eat and at this time a great run-off takes place in the flooded inland. Barramundi and other fish are caught in traps such as the one in the left-hand panel. The trap is a symbol for a container of souls.

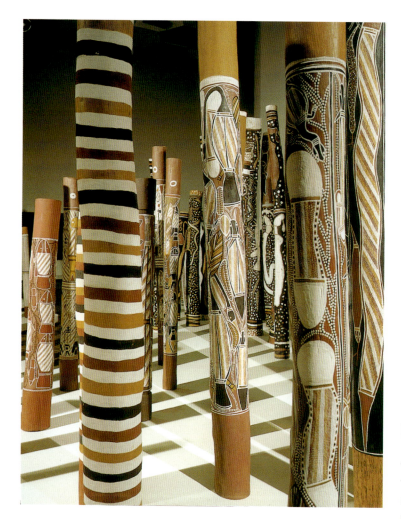

Ramingining Artists

The Aboriginal Memorial 1987–88
natural pigments on wood
heights from 40.0 to 327.0 cm
Purchased with assistance of funds from
National Gallery admission charges and
commissioned in 1987

This monumental installation was completed in 1988, Australia's bicentenary year. It is dedicated by its makers to all indigenous Australians who defended their land and perished in the 200 years of white settlement.

The installation is inspired by the hollow log or bone coffin mortuary ceremony of Arnhem Land. The path through the *Memorial* imitates the course of the Glyde River which flows through the Arafura Swamp to the sea. The hollow logs are situated broadly according to where the artists' clans live along the river and its tributaries.

Themes of transition and regeneration within Aboriginal culture pervade the *Memorial*. On a wider scale, the *Memorial* also marks a watershed in the history of Australian society. Whilst it is intended as a war memorial, it is also an historical statement, a testimony to the resilience of indigenous people and culture in the face of great odds, and a legacy for future generations of all Australians.

The artists who created this installation intended that it be located in a public place where it could be preserved for future generations. The *Memorial* is on permanent display in the National Gallery of Australia.

Thancoupie b.1937
Thanaquith people
Moocheth, the Ibis; Arough, the Emu; Golpondon, the Ibis's son 1988
stoneware
27.7 x 30.7 (diameter) cm
Purchased from National Gallery admission charges 1988

Thancoupie is one of Australia's leading ceramicists, and one of the first contemporary Aboriginal artists to be recognised in the international art world.

While she draws inspiration from the traditions of her people — the Thanaquith from Cape York Peninsula in northern Queensland — Thancoupie has developed a vehicle for personal artistic expression in her ceramics. There is no history of pottery in traditional Aboriginal society, although clay has a significant role in ceremonial activity and in art. The Thanaquith traditionally baked clay balls, which were stored to make paint for use in rituals.

The Thanaquith's affinity with clay has been translated into Thancoupie's spherical pots which are symbolic of unity, fire and mother earth and are decorated with images from traditional stories.

This vessel relates to the episode in Thanaquith people's Dreaming where Arough and Moocheth's relatives and a great dancer were overcome by the Ibis's jealous husband.

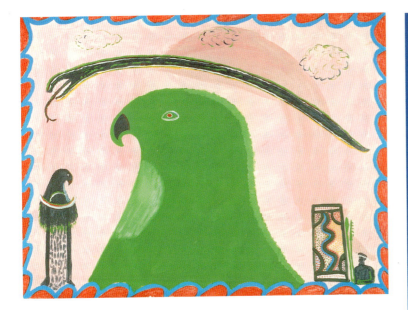

Ginger Riley Munduwalawala

b. c.1937

Mara people

Ngak Ngak the Sea Eagle 1988

synthetic polymer on canvas

27.7 x 121.0 cm

Moët & Chandon Fund 1991

Reproduced courtesy of Alcaston Gallery, Melbourne

Ginger Riley Munduwalawala's paintings feature a compendium of the ancestral beings who created his clan's, the Mara's, country which lies around Limmen Bight, beyond the south east of Arnhem Land on the Gulf of Carpentaria.

Ngak Ngak the Sea Eagle, who created Yumunkuni Island in the mouth of the Limmen Bight River, is omnipresent in the body of Ginger Riley's work, observing the creative dramas that unfold in the Dreaming, an allegory, perhaps, for the artist bearing witness through the eyes of his avian totem to the events that are depicted in the canvases. As such this image of Ngak Ngak may be considered as a type of self-portrait or a reflection of Ginger Riley's identity.

Ginger Riley usually paints the totemic sea eagle white, but has painted it here for visual effect, indeed to lend the image a certain brilliance. Ginger Riley's paintings also feature rectangular message sticks or boards which announce initiation and circumcision rites, or invite people to his country. The message sticks are flanked by two snakes, or by a human figure, as on the right.

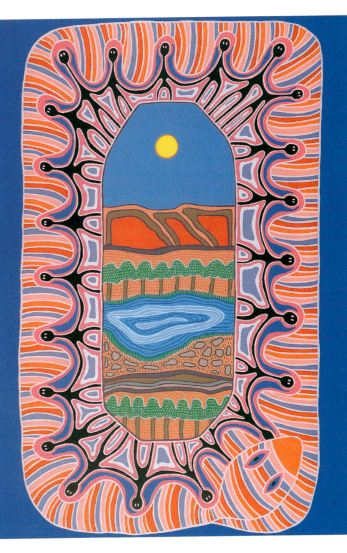

Sally Morgan b.1951

Wanamurraganya 1989

colour screenprint

75.8 x 50.2 cm (comp);

106.2 x 75.0 cm (sheet)

Gordon Darling Fund 1990

The sharp multi-layered screenprints of Sally Morgan challenged public perceptions of Aboriginal artistic practice in the 1980s. Sometimes requiring up to 37 colours, their appearance helped to expand the notion of the four primary ochres needed to 'authenticate' indigenous art. In 1987, Sally Morgan published a book, *My Place* (Fremantle Arts Centre Press, Western Australia), which became one of the best selling works by an Australian author at that time. It dealt with questions of Aboriginal identity that found a response with many immigrant Australians.

The print takes its title from Morgan's second novel in 1989, *Wanamurraganya: The Story of Jack McPhee* (Fremantle Arts Centre Press, Western Australia). It tells the true story of Jack McPhee, a former pastoral worker whose entire life had been recorded in government files and documents. The layered landscape in *Wanamurraganya* is Jack McPhee's country in the Pilbara region of Western Australia. Rendered in 'portrait' form, it is surrounded by human figures, giving the sensation of entering the landscape from a great height and descending beneath the earth. The print was created for the cover of the book in consultation with McPhee after extensive research for the project.

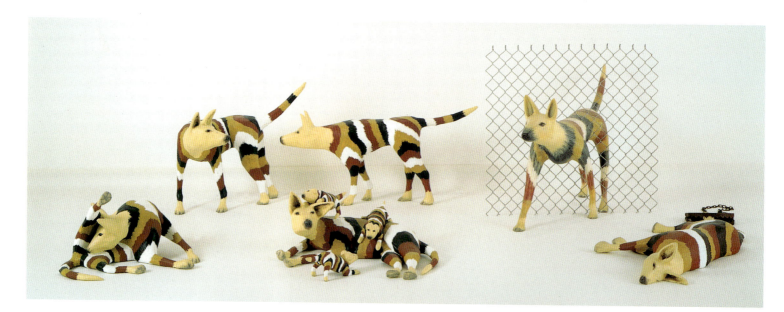

Lin Onus 1948–1996
Yorta Yorta people
Dingoes 1989
synthetic polymer paint on fibreglass,
wire, metal
maximum height 95.0 cm
© Lin Onus 1989. Reproduced by permission
of VI$COPY Ltd, Sydney, 1997

The fibreglass dogs in Onus's
installation are painted in stripes
of red, yellow, black and white,
the four basic Aboriginal colours
used in art. The sculpture is a
sympathetic, somewhat
humorous but ironic comment on
popular perceptions of a much
maligned indigenous dog:
the word 'dingo' has entered
non-Aboriginal Australian parlance
to mean a despicable person or
coward. In one detail, the spirit
dog breaches the dingo fence
which runs across thousands of
kilometres to protect introduced
grazing animals, cattle and sheep,
and serves as a metaphor for the
historic treatment of Aboriginal
people. However, as Onus once
observed, 'there are dingoes on
both sides of the fence!'

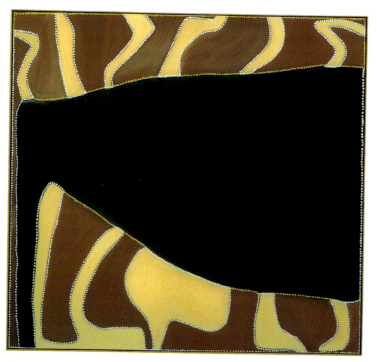

Rover Thomas b.1926
Kukatja/Wangkajunga people
Cyclone Tracy 1991
natural pigments on canvas
168.0 x 183.0 cm

On Christmas Eve 1974, Cyclone
Tracy destroyed the city of Darwin.
The cyclone was interpreted by
Aboriginal elders in the nearby
Kimberley region as the ancestral
Rainbow Serpent destroying the
centre of European culture as
a warning to Aboriginal people
to keep their culture strong.

As a result, a number of
ceremonies were conducted in
public, among them the Krill Krill
which is owned by Rover Thomas.
The Krill Krill tells of the travels
of the spirit of a deceased woman
from the place where she died,
off the coast of Derby in the west,
to home in the east near
Kununurra where she witnessed
the destruction of Darwin.

This painting expresses the full
force of the wind; the black form
represents the cyclone gathering
intensity as it heads towards and
engulfs Darwin. Minor winds,
some carrying red dust, are shown
feeding into the main image.

*Ngumuli warra tawun pirringa.
(Looking across from Kununurra
they see that Darwin has been
flattened by the cyclone. The Rainbow
Serpent destroyed Darwin.)*
Rover Thomas, 1983, from the
Krill Krill song cycle, recorded and
interpreted by Dr Will Christensen
in 1983.

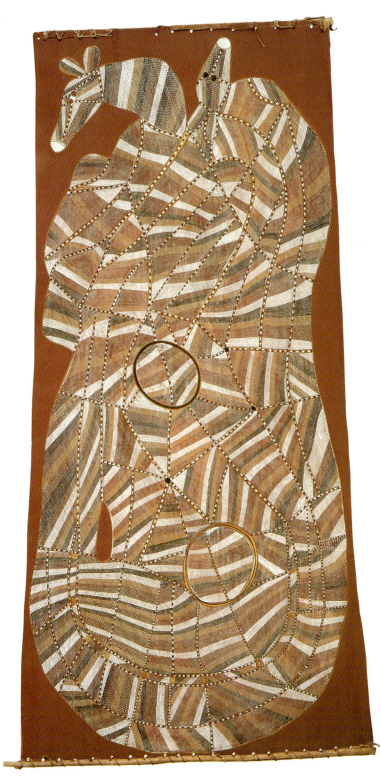

John Mawurndjul b.1952
Kuninjku people
Rainbow Serpent's antilopine kangaroo
1991
natural pigments on eucalyptus bark
189.0 x 94.0 cm

Supernatural beings in the forms
of Rainbow Serpents are among
the most important creator beings
in many parts of Aboriginal
Australia and in particular in the
western part of Arnhem Land.
To the Kuninjku people, Yinarnga,
shown here in the form of
a Serpent, is the first ancestor,
mother of all.

*Rainbow Serpent's antilopine
kangaroo* shows a horned Yinarnga
giving birth to the Rainbow
Serpent Djangkarla in the guise of
a kangaroo. Djangkarla's kangaroo
head can be seen in the top
left-hand corner of the painting,
and Yinarnga's to the right. The
protrusions on the upper chests
of Djangkarla and Yinarnga
represent the gullet of emus in
which they store the food they will
later regurgitate and swallow
again. The detail alludes to the
concept of transition through the
process of swallowing and
regurgitation, comparable to the
effects of initiation ceremonies
where participants are said
to be 'swallowed' by the ceremony
and regurgitated in a higher
ritual status.

The painting is dominated
by Mawurndjul's sweeping
patterns of *rarrk* or cross-hatching
which create a shimmering optical
effect to place the subject in the
realm of the spiritual rather than
the physical.

Judy Watson b.1959
Heartland 1991
powder pigments, pastel on canvas
176.0 x 173.5 cm

In the paintings of Judy Watson,
history is embedded in the land
which is marked with the evidence
of past events; the concepts linking
land, family and history are
expressed in her work. Washes
of paint and marks in dry pigment
combine to produce textures
of stone, water and earth, and refer
to the presence of her ancestors
in the land. Paintings such as
Heartland are tactile maps of her
ancestors' country, that of the
Waanyi people of north western
Queensland.

*walking around my country/ looking
at things/ being shown important
sites/ making connections with family
and land/ fishing, talking/ sharing
food and laughter/ going back to the
place/ where my grandmother and
her/ mother were born/ going back
there with my grandmother/ going to
places I've read about/ in libraries/
the history of our people before/ and
after the pastoral invasion/ the impact
on my family/ seeing the country
through/ my grandmother's eyes/
learning about the bush foods/ going
back to the city/and making work/
space/ heat/ dust/flies/ throwing the
cast net/ thinking about country*
Judy Watson, *Imprint*, 1991,
vol. 27, no. 1.

Emily Kame Kngwarreye *c.*1916–1996
Ammatyerre people
The Alhalkere suite 1993
synthetic polymer paint on
22 canvases
each 90.0 x 120.0 cm
© Emily Kame Kngwarreye 1993. Reproduced
by permission of VI$COPY Ltd, Sydney, 1997

The Alhalkere suite is a
monumental installation of 22
canvases which evokes the cycles
of nature in the land and the
spiritual forces that imbue it.
It is a response to the artist's
country, Alhalkere, the desert
country of Kngwarreye's birth.

In this major work she revisits
many themes and techniques of
her earlier paintings. It describes
the land in flood, fertilised by
water: rains and storms in early
spring. It also celebrates the
coming of water after long years
of drought as so often happens
in the desert. After the rain,
carpets of wildflowers and the
soft-looking spinifex bushes appear
beside the desert oak trees and
blossoming wattle.

The work is a benchmark
in the artist's œuvre; her later
canvases being minimal in colour
and application of paint,
sometimes using simple black
on white to trace the sacred Yam
awelye or women's designs.

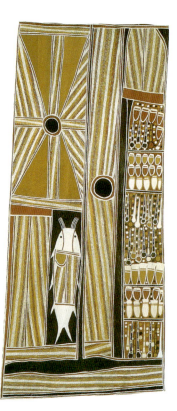

David Malangi b.1927
Manyarrngu people
Dhamala story 1993
natural pigments on eucalyptus bark
180.0 x 100.0 cm

*The two Djan'kawu Sisters came
from the east; they changed their
language when they got to Dhamala.
They named the people and the places
and became part of the tribe. This is
Milmindjarrk where the waterhole is
[top left]. This area is called
Dhamala at the mouth of the Glyde
River.* David Malangi

The painting depicts a coastal
landscape of northern Arnhem
Land as a map. The map is
conceptual and ancestral, and
is not intended to be
topographically accurate. The black
line across the bottom of the
painting represents the coastal
waters of the Arafura Sea and the
central vertical line is the Glyde
River. Dhamala is on the left,
western, bank of the river.
The catfish, Djirrkada, was caught
and named by the Djan'kawu.

The right half of the painting
depicts Ngurrunyuwa, on the
eastern side of the river. As they
approached the tree line, the
Djan'kawu saw flocks of black
cockatoos. The Djan'kawu Sisters
rested in the shade of a tree and
cleaned their hair of lice. They
hung their dilly bags on the
branches and went to the
mangroves to gather crabs, berries
and bulbs, and to catch fish.

The panel depicts one of the
foods collected by the Djan'kawu:
it is *rakay*, the spike-rush (the
pointed shapes), its corms (the
white shapes) and the leaves.

Ngurrunyuwa is also associated
with Gunmirringgu, the great
ancestral hunter. He is connected
with Manyarrngu mortuary
ceremonies. A rock is depicted
at the top of the panel — this is
Garangala, which was formed
when Gunmirringgu threw his
spear into the sea.

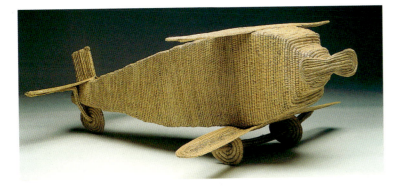

Yvonne Koolmatrie b.1945
Ngarrindjeri people
Bi-plane 1994
woven sedge grass
113.0 x 50.0 x 135.0 cm

Well I did see Janet Watson's Bi-plane (in the collection of the South Australian Museum). She is a lady from the South-east, from Kingston, but I had plans to do it much bigger and a different style. I think she used rushes called 'pinkies', and I just used rushes from along the river. I started from the front and I weaved right down to the tail. I did the wheels and wing after. There is no-one else who I can ask (for technical advice). I have to work it out myself. Like this old basket that I have. I think it was (made by a Rankine). I thought to myself that I want this thing to last, I didn't want wire in it, that's going to rust, so I used bullrushes to strengthen it. I've got to experiment 'cause all the old people are gone. When Auntie Doreen taught us, she just showed us so much, where to find the rushes and how to soak and weave them. Well, after that she got too sick to go on teaching and before I had got back to her she had passed away. When I do pieces I always think of her. I don't know if she is still guiding me. She still inspires me to carry on.
Yvonne Koolmatrie.

The Ngarrindjeri people of the Coorong region, an expanse of coastal sand dunes at the mouth of the Murray River in South Australia, traditionally use the technique of coil woven sedge grass to make eel traps and baskets.

Angkuna Kulyuru b.1943
Pitjantjatjara people
Untitled 1994
batik on silk 300.0 x 120.0 cm

In the desert areas of Australia, women traditionally spin animal fur and human hair into string with which to make skirts, belts, headbands and head-rings for carrying bowls. Since 1948, with the introduction of the pastoral industry to the region, Pitjantjatjara women at Ernabella have spun and woven sheep's wool into products ranging from traditional carrying bags to non-traditional belts, scarves and floor rugs. These items incorporate designs which the Pitjantjatjara women also produced in crayon drawings and watercolours based on traditional women's designs called *yawulyu*.

The production of weavings was largely replaced by the introduction of batik techniques in 1972. The use of the *canting* (wax pen), paintbrushes, waxes and dyes allowed for new elaborations on *yawulyu* on silk and cotton fabrics. Angkuna Kulyuru's fabric-length is characteristic of Pitjantjatjara batik designs; it shows organic forms based on leaves, flowers and plants, composed in a manner which owes something to the traditional Javanese batiks with which several Ernabella artists are familiar. The arrangement also relates to the formal compositional structures of contemporary acrylic paintings.

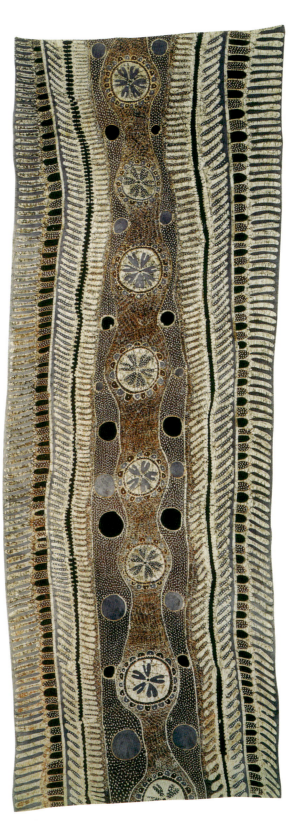

While many of the paintings, especially those by men, take an expansive and heroic view of country, the women's batiks build images based on a knowledge of the more intimate details of the land.

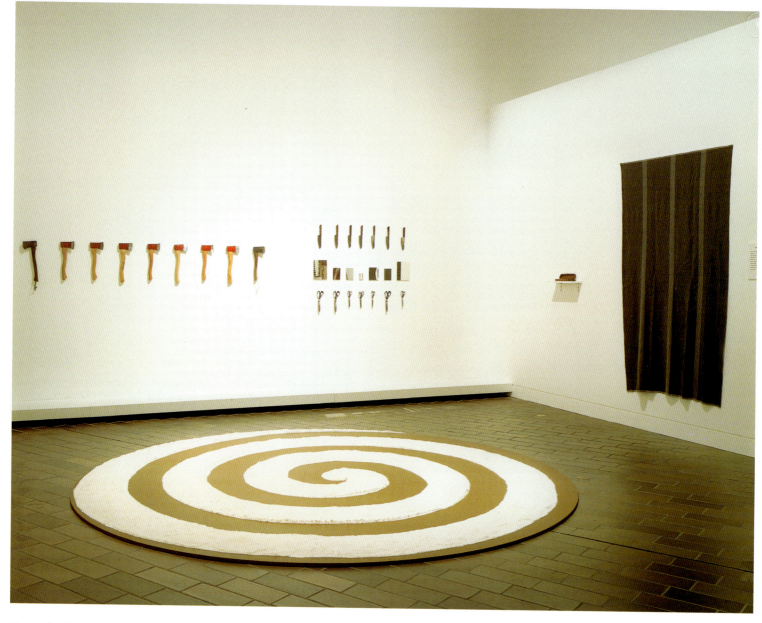

Fiona Foley b.1964
Badtjala people
Land deal 1995
flour, mixed media, found objects,
text
spiral 442.0 cm diameter; wallpieces
maximum height 202.0 cm
Courtesy of Roslyn Oxley9 Gallery

On 6 June 1835, John Batman attempted to buy land around Port Philip Bay, now the city of Melbourne, from the local Aboriginals. In his journal Batman wrote:

After a full explanation of what my object was, I purchased two large tracts of land from them — about 600,000 acres, more or less, and delivered over to them blankets, knives, looking glasses, tomahawks, beads, scissors, flour, &c., &c., as payment for the land; and also agreed to give them a tribute, or rent yearly.

This unfair deal was disowned by the government of the day — they would be the negotiating authority if any was to be done. In fact this was to be the only recorded attempt at such a purchase contract in the history of black and white relationships in this country. Foley's work and its acquisition by a public institution constitute a delicious irony: items similar to those which Batman wished to trade have been officially purchased for the Australian nation.

The spiral arrangement of flour on the floor places the work within Aboriginal art practices. Historically it follows the Aboriginal religious iconography of south east Australia by duplicating similar grooved designs etched in the ground for ceremonies. In a wider sense it follows an Australia-wide Aboriginal practice of 'ground drawings' in sand, coloured ochres and soil, in light of the fact that Foley's people's land, Thoorgine (Fraser Island, north of Brisbane) is the world's largest sand island.

Dula Ngurruwutthun b. *c.*1936
Munyuku people
Munyuku Wana 1995–96
natural pigments on eucalyptus bark
314.0 x 86.0 cm

The themes and totemic designs represented in this painting link the Munyuku and Warramirri clans of North Eastern Arnhem Land who are symbolised by two types of country: salt and freshwater, coastal and inland, which are related to the ancestral whale, Mirinyunu.

The region depicted at the bottom of the painting incorporates both the sand dunes and the ocean of the Munyuku: Rurranala, bush country identified by a freshwater river, and Yarrinya, a beach-side homeland along the coastal salty waters. The whale's tail can be seen in sections: it had been cut up by spirit men with their stone knives that were later thrown into the ocean hitting a sacred submerged rock (centre panel). The black triangular design represents Ganburrk, the smell of the whale carcass.

The central panel of the painting shows Garapana, the highly sacred rock. Octopus and the turtle called Wurrwakunha inhabit these dangerous sacred waters. The octopus is a totem that links both the Munyuku and the Warramirri clans.

In the top panel the narrative continues inland to freshwater country where a waterhole was created by the ancestral being, Lany'tjung. The diamond design is the sacred clan design for Munyuku people representing both *birrkuda* (honey) and freshwater.

The *miny'tji* (sacred cross-hatched designs) in the second panel refer to Muthali the Black Duck. During the times of creation, when great floods

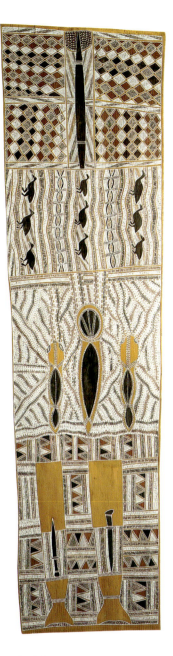

washed the country, a woman called Muthali changed into the duck and flew away. Several more black ducks became a chain of islands now known as the English Company Islands.

Ken Thaiday b.1950
Meryam Mîr people
Shark mask 1997
mixed media
87.0 x 60.0 x 110.0 cm

Thaiday is best known for his imaginative shark headdresses. In the Torres Strait, the shark is a symbol of law and order. The shark mask, worn by male dancers only, is traditionally associated with the Bomai-Malu cult. The shark is represented by large jaws which hide the wearer's face, the menacing teeth mitigated by rows of feathers attached to the jaws. An image of a hammerhead shark appears on the crown, the mask designed to extend high above the dancer's head and cover much of the upper chest.

The assemblage on a wooden frame allows manipulation of both the jaws of the shark and the shark effigy independently. By operating the strings and hinges the jaws open and close and move the effigy from side to side imitating feeding movements.

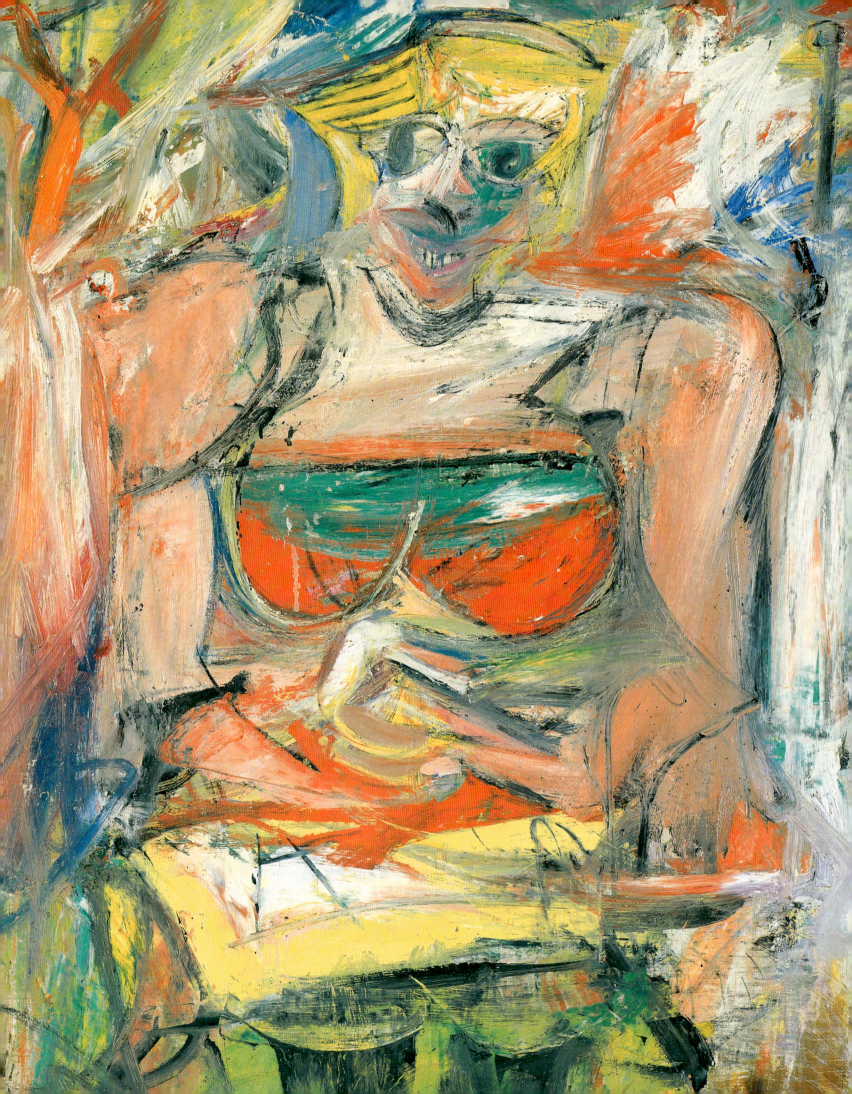

INTERNATIONAL ART

The international collection of the National Gallery of Australia is introduced by a small but historically significant group of European works from before 1800, exemplified by Peter Paul Rubens's *Self-portrait* of 1623 and Giambattista Tiepolo's *Marriage allegory of the Cornaro Family* (*c*.1750). The Gallery's collection is essentially modern and the representation of European and American art parallels the recorded history of Australian art over the past 200 years and finds its strength in the 20th century. The collection develops and expands from the beginning of the 19th century in a variety of media which includes painting and sculpture, the strong collection of prints, posters, illustrated books and drawings, a near-complete representation of the history of photography, an excellent representation of theatre arts and the decorative arts. These interdependent collections allow an appreciation of Western art from abroad and its substantial impact on Australian art.

The first purchases of international art were made in 1971 and two years later the Gallery acquired Jackson Pollock's *Blue poles* (1952), announcing to the world a serious ambition to form a significant international collection. This purchase was followed by two important acquisitions in the following year: Willem de Kooning's *Woman V* (1952–53) and two versions of Constantin Brancusi's *Bird in space* (1931–36). The Felix Man Collection, a comprehensive body of works which shows the history of lithography from its beginnings at the end of the 18th century, was also acquired at this time. Francisco Goya's *Division of the arena* (1825) is a fine example of the early use of the lithographic technique. Over the following decade the Gallery continued to lay down what would become the keystones of the modern collection.

The acquisition of works for the collection has been assisted by a number of generous donors. Dr Orde Poynton has supported the Gallery in its collecting works on paper; Gordon and Marilyn Darling have donated a stained glass window by Frank Lloyd Wright; Victor and Loti Smorgon have contributed to the acquisition of a number of significant international paintings; Tony and Carol Berg have gifted a fine collection of German expressionist prints; and the American Friends (AFANG) have also assisted the acquisition of significant works of art.

The 30 years that the Gallery has been collecting is a short span when compared to the history of the development of many overseas museum collections. In those 30 years, however, the Gallery has built collections of international significance. The early commitment to collecting photography has been rewarded with an enviable collection, which records the evolving technology of photography and the increasing awareness of its potential as an expressive medium. The holdings range from W.H. Fox-Talbot's portfolio of calotypes, *Pencil of Nature* (1843) to confronting contemporary images by Cindy Sherman.

Since the acquisition of the Felix Man Collection, the print collection has grown substantially to encompass the diverse range of techniques used by artists from 1800 to the present. Outstanding posters such as Pierre Bonnard's joyous *France-Champagne* (1891) were made to be reproduced in quantity, while Erich Heckel's *Portrait of a man (Self portrait)* (1919), a hand-coloured wood cut, is unique. The collection also holds drawings of quality, such as Henri Matisse's virtuoso charcoal drawing *Romanian blouse* (1938).

Key works in the decorative arts collection represent the output of leading designers. The collection ranges from the work of Christopher Dresser and Josef Hoffmann — two of the 19th century's industrial designers who contributed to classic modernism — up to the irreverent inventions of today by Ettore Sottsass and the Memphis group. Frank Lloyd Wright, one of this century's most influential architects, is represented with a number of works, including a striking red and white *Leaded glass window for the Avery Coonley Playhouse* (*c*.1912). The Gallery's collection of Theatre Arts comprises a major holding of the work of artists who designed for Serge Diaghilev's Ballets Russes. Among the fine costumes in this collection is Léon Bakst's sumptuous tunic from the original costume worn by Nijinsky in the lead role of the ballet *The Blue God*.

As well as collecting the work of significant modern artists, the National Gallery is attempting to build a contemporary collection that reflects current directions. The collection includes work by Joseph Beuys, Francis Bacon, Chuck Close and Jannis Kounellis. Anselm Kiefer's powerful *Twilight of the West* (1989) is already one of the most popular paintings in the collection.

As well as the collections of European and American art, the National Gallery's international collection includes a small but select group of objects and textiles from Africa and from pre-Columbian America. Works such as the carved wooden Senufo mask from East Africa impress with their own aesthetic and distinct canons of beauty and proportion.

The collection of the National Gallery of Australia is premised on the belief that an understanding of modern art involves an appreciation of the way in which the work of non-Western visual culture profoundly influenced the direction of art in our century.

Olmec people, Guerrero, Mexico
Portrait mask c. 1200–800 BC
jadeite
18.0 x 16.6 x 7.0 cm

The Olmec culture is considered to be the first major civilisation of Central America. The Olmec ruled an area covering most of modern day Mexico from about 1300 BC to 600 BC.

The Olmec believed they were descended from the union of a jaguar and a woman. Their divine rulers, direct descendants of this marriage, built large cities with pyramids and temples. They amassed enormous wealth and were given ostentatious burials.

Olmec artists were proficient in a range of materials from fine ceramic figures, especially of naturalistic human forms, monumental stone heads between 1.5 and 3 metres tall, and exquisite sculptures in semiprecious stones.

This mask probably represents an Olmec ruler. The mask's naturalism indicates the human aspect, however the curve of the upper lip suggests the features of the divine jaguar.

Senufo people, Ivory Coast, Africa
Mask, with serpentine nose and prominent rounded mouth
19th century
wood
27.1 x 14.4 x 8.5 cm

Members of the large Senufo tribe live in the northern Ivory Coast, southern Mali and upper Volta. The dominant male grouping, known as Lo, is the main source for and employer of Senufo sculpture, mainly figures and masks, in both human and animal form. A significant feature of Senufo culture, masks are used for covering the face and as 'helmets'. This one is unique: its astonishing stylisation of the human face is enhanced by the patina and extreme thinness of the wood. The bulging brow, slit eyes and cylindrical mouth contrast dramatically with the zigzag nose, shown in slim relief in the form of a serpent.

Djenne, Mali
Horse and rider 14th century
terracotta
66.0 x 38.0 x 12.0 cm

During the 13th and 14th centuries, the city of Djenne on the Bani River, a tributary of the Niger in present day Mali, was a major mercantile centre at the crossroads of the caravan trade across the Sahara desert. Djenne was also home to a remarkable school of ceramic figure sculpture, known for works featuring elaborate details of costume, jewellery and other adornments. Among the most ambitious images, a small group of works represents clothed and armed horsemen. Here, as throughout west Africa, the horse was not used for agricultural purposes but to carry noble or priestly persons.

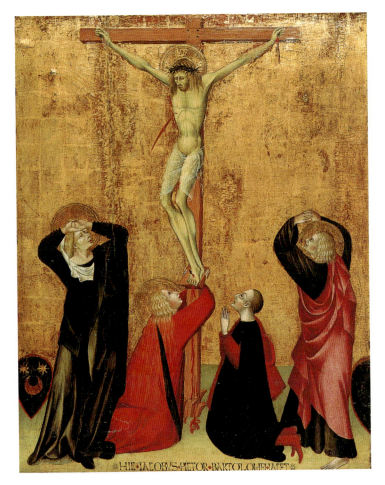

Giovanni di Paolo *c.*1403–1483
Crucifixion [with donor Jacopo di Bartolomeo] *c.*1455–60
tempera, gold leaf on panel
114.2 x 88.5 cm

By the mid 15th century, the period of great public commissions in Siena had largely passed; and, with the exception of parts of the cathedral in Siena, most of Giovanni di Paolo's work was for wealthy private patrons. This painting was commissioned as a commemorative altarpiece to be placed over the tomb of a 15th century Sienese painter, Jacopo di Bartolomeo (Jacob, the son of Bartholomew). Jacopo, as the donor, is himself shown kneeling at the foot of the crucified Christ, along with the Virgin Mary, Mary Magdalen, and St John; Jacopo's heraldic shield is placed at the left of the picture. The work is both a traditional meditation on

the death of Christ and a unique portrait of an artist of this period. The Crucifixion is one of the earliest of the Gallery's major European works; within Giovanni di Paolo's own œuvre, it is the most exquisite and the best preserved of his Crucifixion scenes.

Peter Paul Rubens 1577–1640
Self-portrait 1623
oil on canvas
84.0 x 60.0 cm

Peter Paul Rubens was arguably the most important Baroque artist working in Europe in the 17th century. He was also a successful courtier and diplomat who represented the Spanish Netherlands in the courts of Europe from 1620 to 1633. In 1623 the 45-year-old artist painted two self-portraits. One, on panel, was sent on request to Charles, Prince of Wales (later Charles I of England), and is today at Windsor castle. The second self-portrait, an almost identical composition, was made for Rubens's friend, the scholar and lawyer Nicolas-Claude Fabri de Peiresc. In this second

self-portrait, belonging to the National Gallery of Australia, Rubens has painted himself in full court dress to emphasise his status as a gentleman of Antwerp.

Francisco Goya 1746–1828
Division of the arena from the series
The Bulls of Bordeaux 1825
lithograph
30.4 x 41.4 cm
Felix Man Collection, Special Government
Grant

Famous for his etching series
The Disasters of War, Francisco Goya
learnt the new technique of
lithography when he was living in
southern France in the 1820s, exiled
from reactionary Spain. In *Division
of the arena* he returns to a national
theme: the blood, death and
excitement of the bullring.
He depicts the passions of the crowd
and the space of the arena,
expressing them as darkness and
light. The artist isolates the action
by using white to pick out the
action, like a wandering spotlight,
the focus moving over the ring and
the febrile public. Observing from
above, Goya uses the clarity of white
paper and the gradations of his
black lithographic crayon to
delineate the drama of the bullfight
and the restlessness of the audience.

Giambattista Tiepolo 1696–1770
Marriage allegory of the Cornaro family
c.1750
oil on canvas
343.0 x 172.0 cm

Giambattista Tiepolo was the most
sought-after painter of his time in
18th century Venice, known for his
ability to create illusions of space
and light. This painting is believed
to have been originally a ceiling
panel for a palace in Venice, which
explains its somewhat distorted
perspective. In the centre of the
canvas sit a bride and groom
surrounded by numerous symbols
of a happy marriage. The couple
are literally fastened together
by a gold chain, from which hangs
a pendant heart. Beneath them sits
a dog, representing faithfulness,
next to a quiver of arrows probably
dropped by Cupid, god of love.
In the clouds are Prudence holding
a mirror, Peace with an olive
branch, and Charity with the white
dove of purity and the flaming
heart of love.

Julia Margaret Cameron 1815–1879
English flowers 1873
albumen silver photograph print
33.2 x 27.4 cm

Julia Margaret Cameron took up
photography late in life after receiving
a camera as a Christmas present
in 1863 and went on to establish a
distinguished reputation as a pioneer
of art photography. Cameron's
compositions conform to popular
spiritual themes and romanticised
story telling popular in the art of her
time but her soft-focus and shadowy
lighting was radically different to the
sharp detail so highly valued in
photography. Cameron did not,
however, regard her works as fictions.
No matter how staged or stylised the
subject, Cameron frequently inscribed
her prints as being 'from life'. This
was not contradictory as she believed
camera art could fix and reveal beauty.

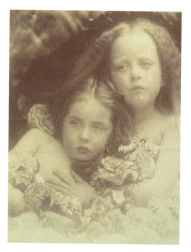

English flowers is a rare late work by
Cameron who made numerous
studies of children as angelic symbols
of innocence and peace. The subject
was reused in 1875 as an illustration
titled *The childhood of Alice and Effie*
in the miniature edition of her
illustrations to Lord Tennyson's poem
Idylls of the King.

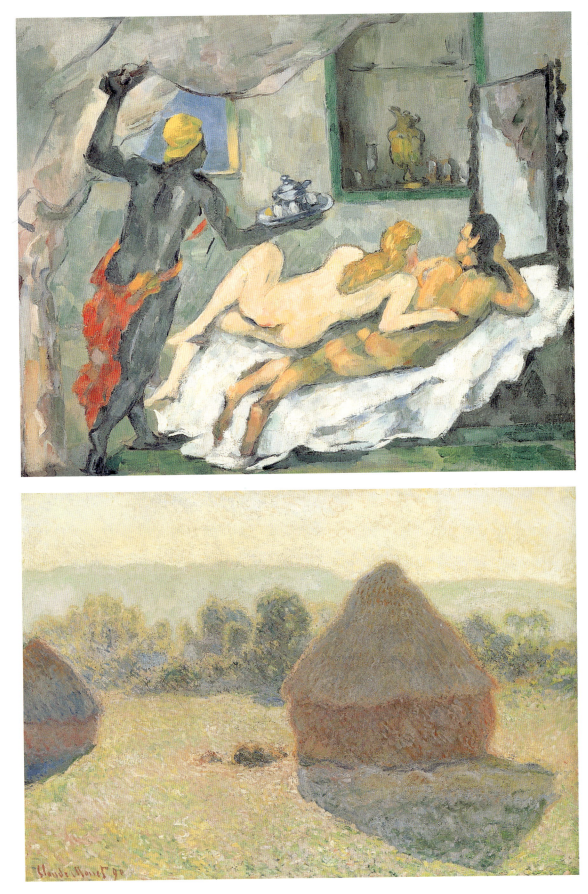

Paul Cézanne 1839–1906
*Afternoon in Naples [L'Apres-midi
à Naples]* c.1875
oil on canvas
37.0 x 45.0 cm

In the early 1870s Cézanne had
worked at Pontoise with Camille
Pissarro, and in this period of his
career his painting style was
influenced by that of the
Impressionists; the brushwork
of the back wall and the drapery
in *Afternoon in Naples* reflects the
Impressionist technique of
cross-hatched juxtapositions of
colour. The theme of this painting
occurs frequently in Cézanne's
early work. A naked couple sprawl
on a rumpled bed, while a servant
brings them a drink. The title and
subject matter of the painting
suggest the common notion at the
time that Italy was a place of
freedom, sensuality and pleasure.

Claude Monet 1840–1926
Haystacks, midday 1890
oil on canvas
65.6 x 100.6 cm

This painting shows two stacks of
sheaves — probably wheat —
thatched for protection against
the weather, and standing in a field
behind Claude Monet's house at
Giverny, a village in the valley of
the river Seine, about 60 kilometres
north west of Paris. From the late
summer of 1890 through the winter
of 1891, Monet worked on at least
25 paintings of these haystacks. The
simple composition enabled him
to concentrate on his real subject —
the changing effect of light rather
than the haystacks themselves.
Monet chose 15 of these grain stack
paintings, each reflecting a different
time of day and different weather
conditions, as the centrepiece of his
1891 exhibition at art dealer Paul
Durand-Ruel's gallery in Paris.
The exhibition was a spectacular
critical and financial success.

Pierre Bonnard 1867–1947
France-Champagne 1891
colour lithograph
78.0 x 57.8; 79.4 x 58.8 cm
Purchased with assistance of Orde Poynton
Esq CMG 1994
© Pierre Bonnard, 1891/ADAGP. Reproduced
by permission of VI$COPY Ltd, Sydney 1997

The finished poster by Pierre
Bonnard for *France-Champagne*
was pasted up in the streets towards
the end of March 1891. The impact
in Paris was immediate. In this one
work Bonnard established the
poster as truly an art form in its
own right and a valued collector's
item. The National Gallery was
fortunate to purchase this work as
it was already a rarity by 1908.

In *France-Champagne* Bonnard
applied the techniques of the fine
art of painting to poster making.
It reveals a Rococo style figure
with tumbling golden hair amid
frothing bubbles shown in a
composition consisting of
luminous flat colours, decorative
patterning and arabesque lines; it
also reflects the vogue for Japanese
prints. It propelled Bonnard into
prominence in the art world. Henri
de Toulouse-Lautrec admired
France-Champagne, and thus
Bonnard was instrumental
in beginning Lautrec's successful
career as a poster artist.

Amedeo Modigliani 1884–1920
Standing nude c.1912
limestone
162.8 x 33.2 x 29.6 cm

While Amedeo Modigliani is best
known as a painter, he once
considered himself primarily
a sculptor, and from 1909 to 1914
he produced at least 25 stone
sculptures. The largest of these,
Standing nude, was carved in soft
limestone in about 1911–12.

In many ways Modigliani's
sculpture remains the work of
a painter. It is carved frontally,
with scant attention to the sides
and back which are left
unfinished. The figure is
decoratively articulated in a play
of line and volume, rhyming the
curves of the oval head, breasts,
belly and knees.

Like Henri Matisse and Pablo
Picasso, Modigliani admired
non-Western art, particularly that
of ancient Egypt and Africa. It was
assumed that art made by peoples
unfamiliar with technology was
more honest because the culture
was in direct contact with nature.
The carving of stone or wood
allowed the artist to confront his
material and record his emotions
without intervention. Modigliani's
sculpture nevertheless is
characterised by an austerity and
remoteness. His standing figure
combines formal authority with
an elegiac air.

Frank Lloyd Wright 1867–1959
Leaded glass window for the
Avery Coonley Playhouse c.1912
glass and lead
61.0 x 97.5 cm
Gift of Gordon Darling AFANG Fund
in memory of Marietta Tree
© Frank Lloyd Wright 1912/ARS. Reproduced
by permission of VI$COPY Ltd, Sydney, 1997

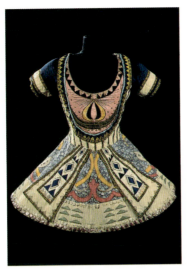

Léon Bakst 1866–1924
Tunic from the Blue God's costume
for the ballet *The Blue God* 1912
silk, glass beads, metal thread and
studs, gelatin discs

Rich and unusual combinations
of colour and fabric combined with
lavish ornamentation were
the hallmarks of Bakst's pseudo-
oriental style. *The Blue God* was
one of the most spectacular
productions staged by Serge
Diaghilev's Russian Ballet and
featured some of the most intricate
and ornate costumes ever designed
by Bakst.

This is the tunic from the original
costume worn by Nijinsky in the
lead role of the Blue God, a character
based on the Hindu deity Krishna.
Typically sumptuous, it combines
pale yellow watered silk, musk-pink
and blue satin, printed floral silk,
velvet ribbon, green, yellow, blue,
pink and gold embroidery, metal
studs, coloured glass beads and
pearlised gelatin discs. The effect
is subtle yet dazzling.

Juan Gris 1887–1927
Checkerboard with playing cards
1915
oil on canvas
65.0 x 92.0 cm
© Juan Gris 1915/ADAGP. Reproduced by
permission of VI$COPY Ltd, Sydney 1997

Cubism, a movement most closely
associated with Pablo Picasso and
Georges Braque, was based on the
analysis of the geometric forms
inherent in all objects. The Cubists
announced that their art was
realistic, but it was a conceptual
realism rather than an optical
realism: things were painted as they
were known, rather than as they
were seen.

To compensate for their
emphasis on structure, the Cubists
tended to favour familiar subject
matter to ensure legibility. As well
as the checkerboard and playing
cards of the title, the table-top
arrangement depicts a pipe,
wine glasses and a newspaper,
Le Journal.

Frank Lloyd Wright, one of
the most influential modern
architects, designed the Avery
Coonley Playhouse for the
daughter of a client. The
schoolhouse and playhouse was
an addition to an earlier residential
commission, Avery Coonley
House, located in suburban
Chicago. Wright attempted
to define purely American style
using the strong horizontality of
his prairie house design which he
reiterates in the playful curves and
lines of the window. Wright's
design is a forerunner
of the later abstract compositions
of Piet Mondrian.

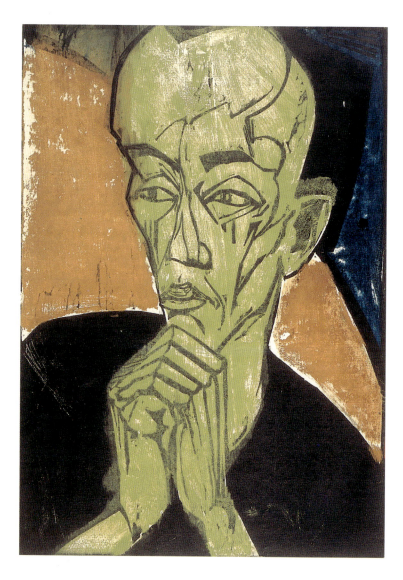

Kasimir Malevich 1878–1935
House under construction 1915
oil on canvas 97.0 x 44.5 cm

Abstract art evolved early this century based on the idea that painting and sculpture are essentially visual languages of colour, line and form. Kasimir Malevich pioneered abstract painting in the years preceding the Russian Revolution of 1917. *House*

under construction (1915) celebrates an optimistic belief in a new age.

Malevich called his abstract works 'Suprematism' which he defined as 'painting of pure form'. Simple blocks of colour spring to life in a dynamic composition that climbs ever upward, the narrative of a society building itself from scratch. From 1916 Malevich gave his paintings abstract titles, calling each one a 'Suprematist painting'.

Erich Heckel 1883–1970
Portrait of a man (Self portrait) 1919
colour woodcut, hand colouring
46.1 x 32.4; 64.2 x 47.8cm
Purchased with the assistance of Tony Berg
© Erich Heckel 1919/Bild-Kunst. Reproduced
by permission of VI$COPY Ltd, Sydney 1997

One of German expressionism's most powerful images is Erich Heckel's *Portrait of a man* which was produced during the uncertain times of World War I and printed in 1919. The image, thought to be a self-portrait, conjures up the trauma of the wartime experience — its build up and aftermath. Heckel had been an ambulance orderly during the fighting and the work captures something of the profound

disillusion, horror and melancholy of the time.

The expressionist movement dominated avant-garde art circles in Germany in the early 20th century and the National Gallery has a collection of prints and illustrated books by key artists such as E.L Kirchner, Käthe Kollwitz, Emil Nolde, Wassily Kandinsky, George Grosz and others. It was a style which was defiantly anti-naturalist and these artists were concerned, not with meticulous finish, but with expression of raw energy, and later with political and social themes.

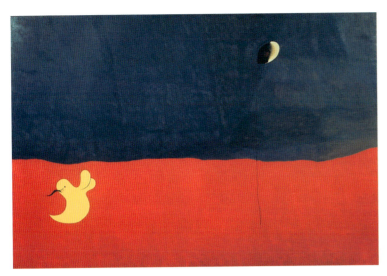

René Magritte 1898–1967
The lovers 1928
oil on canvas
54.0 x 73.0 cm
© René Magritte, 1928/ADAGP. Reproduced by permission of VI$COPY Ltd, Sydney 1997

The Surrealists, a group of artists who first came together in Paris in the 1920s, made dreams a subject for their art. The strange dream-like images in the pictures of the Belgian artist René Magritte, painted in the most matter-of-fact style, had a profound effect on the course of Surrealist painting.

This is one of a small group of pictures painted by Magritte in Paris in 1927–28, in which the identity of the figures is shrouded in white cloth. At first glance Magritte's painting of lovers is slightly humorous. In the mind's eye, however, it becomes curiously disturbing. Sensations of suffocation, even death, surface like remembered dreams or nightmares. This is an image calculated to unlock the darker side of the mind.

Joan Miró 1893–1983
Landscape 1927
oil on canvas
129.9 x 195.5 cm

Miró painted *Landscape* at his family farm at Montroig, a small village 60 kilometres south of Barcelona. It follows the most basic landscape format, being divided horizontally into two zones — a flat red ground at the bottom of the canvas and a deep blue sky above. Against this abstract background the artist has painted two curious items. He identified the yellow shape on the left as a rabbit, and the circle in the sky as an egg.

The rabbit and the egg are simultaneously symbolic and abstract. Miró had been part of the Surrealist group for some time, recreating dreamlike forms in ethereal, unreal spaces. However he did not attempt to paint his dreams or to transcribe his memories. Instead, he was inspired by natural phenomena: 'I was very aware of wide, empty spaces punctuated by one tiny object,' Miró later recalled. 'I was particularly inspired by the Cornudella, near Montroig, where my grandfather came from; the soil is so incredibly red.' Stripped back to the essence, Miró's *Landscape* takes on a near-hallucinogenic quality.

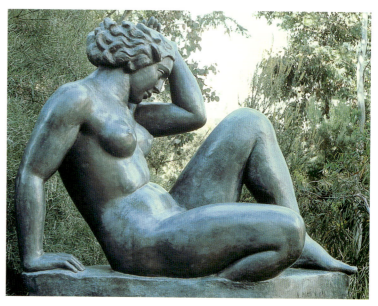

Aristide Maillol 1861–1944
The mountain [La montagne] 1937
lead
167.4 x 193.0 x 82.3 cm
© Aristide Maillol, 1937/ADAGP. Reproduced
by permission of VI$COPY Ltd, Sydney 1997

Henri Cartier-Bresson b.1908
*On the banks of the Marne, France
1938*
gelatin silver photograph printed
*c.*1980
24.2 cm x 36.1 cm (comp);
30.6 cm x 40.6 cm (sheet)
© Henri Cartier-Bresson / Magnum Photos

Constantin Brancusi 1876–1957
Bird in space 1931–36
black marble, white marble,
sandstone base reconstructed 1982
height 211.4 cm
Bird in space 1931–36
white marble, limestone, sandstone
base reconstructed 1982
height 211.4 cm
© Constantin Brancusi, 1936/ADAGP.
Reproduced by permission of VI$COPY Ltd,
Sydney 1997

From a sawn sandstone base, a jet
of polished marble soars upwards:
Constantin Brancusi's *Bird in space*
does not resemble the external
physical appearance of a bird, but

the way our eyes feel and follow
this form provokes a powerful
sensation of effortless elevation.
That sensation, the flash of a bird's
spirit, was Brancusi's subject.
Bird in space exists in 16 versions,
an aeriform blade of polished
marble soaring upwards in such
precarious balance that the
sculptor was obliged to anchor
it with a metal rod which runs
from the base into the body of the
sculpture. Marble had never been
made to behave like this.
The Gallery's birds are the artist's
finest marble versions of *Bird in
space* and the black one is the
tallest he ever carved.

Aristide Maillol's figures are
almost entirely representations
of the mature female nude.
Inspired by Roman and Greek
classical traditions, Maillol imbues
his sculpture with robust
sensuality and monumental
dignity. Using Dina Vierny as
his model, Maillol made four
different preparatory studies for
The mountain. These were cast
in both bronze and terracotta,
in editions of six; one of these
studies, in bronze, is also in
the collection.

For the final, larger-than-life
version of *The mountain* Maillol
chose to use lead — rather than
the more usual material of bronze
— burnishing the surface to give
The mountain a special optical
density. Dina Vierny's recollection
was that the title of the work did
not imply a reference to a specific
locale or geographic feature, but
was 'purely allegorical'.

A scene of people enjoying
themselves in a natural setting
was a popular theme in painting
long before the French painter,
turned photographer, Henri
Cartier-Bresson crept up quietly
behind a portly group in mid-feast
on the banks of the Marne in
France. Cartier-Bresson brought
to his interpretation of the theme
in the 1930s his skill with the
Leica: the first modern miniature
camera. The flexibility of the Leica
enabled him to make an image
which simultaneously presented a
moment in time, framed the group
within the geometric structures
and bold patterns of modern art,
and rendered the sensuous
physical details and tones of the
scene.

The scene on the Marne affirms the simple pleasures of the people, reflecting Cartier-Bresson's own political allegiances. Cartier-Bresson was interested in capturing life through both the chance encounter as well as more directed compositions. His description of the 'decisive moment' at the heart of his work and his many publications have become famous and inspired a world-wide school of documentary photography.

The art of drawing is prized for its directness: the artist makes his or her marks onto paper, with reworking left visible. Charcoal, the remains of burnt wood, can be used as a fine edge, drawn in strong thick black lines, or shaded into grey. In *Romanian blouse*, Henri Matisse redraws the model's features over the smudged charcoal more sharply, with evidence of previous marks showing through.

Matisse draws quickly, his simplified lines outlining the model's head and torso, with strong sinuous curves in the locks of her hair and the neck of the blouse. Distinctive in her decorative embroidered blouse, the model appears to lean into the artist's (and the viewer's) space. She is compressed onto the page, shown in a partial view by cropping at the top and sides.

Henri Matisse 1869–1954
Romanian blouse 1938
charcoal on paper
60.6 x 40.8 cm
© Henri Matisse, 1920/Succession
H. Matisse. Reproduced by permission
of VI$COPY Ltd, Sydney 1997

Willem de Kooning 1904–1997
Woman V 1952–53
oil on canvas
154.5 x 114.5 cm
© Willem de Kooning, 1934/ARS.
Reproduced by permission of VI$COPY Ltd,
Sydney 1997

The American character of the abstract-expressionists lay not only in the scale and the unified, monolithic impact of their paintings but in the sharp, abrasive subject matter. Willem de Kooning's *Woman V* is one of the most representative paintings of the entire movement in this respect. *Woman V* belongs to a series of six paintings made by de Kooning between 1950 and 1953 that depict a three-quarter-length female figure. It is painted with a fury and energy which makes few concessions to the pictorial decorum. De Kooning stated that the Mesopotamian figures on display at the Metropolitan Museum, New York, influenced him when he was creating this series of 'woman' paintings. The wide eyes, smiling mouths, prominent breasts and tapering arms of these figures are echoed in the features of *Woman V*.

Jackson Pollock 1912–1956
Blue poles 1952
enamel and aluminium paint
with glass on canvas
210.4 x 486.8 cm
© Jackson Pollock, 1952/ARS. Reproduced
by permission of VI$COPY Ltd, Sydney 1997

The purchase of *Blue poles* by the National Gallery of Australia in September 1973 for US$2 million unleashed a storm of controversy in the press; subsequently, the work has become the best known in the collection.

Spontaneity — an idea inherent in modern art, reaches a climax in Jackson Pollock's 'drip paintings' in the late 1940s. Pollock abandoned upright painting, preferring to work on the floor, moving around his canvas, pouring, spotting, dripping and puddling paint from brushes, sticks and syringes. *Blue poles* is an outstanding example of these processes. From the delicate and complex paint layers built up on the surface, it is clear, however, that *Blue poles* was not completed in a single burst. Pollock avoids focal points that, in more conventional painting, deliberately

arrest attention or slow the eye. Instead, roaming back and forth over the picture, we are continually attracted by the work's overall liveliness: *Blue poles* is carefully structured so that sensations of energy and spontaneity endure.

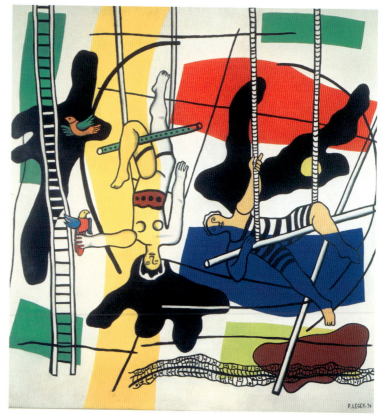

Fernand Léger 1881–1955
Trapeze artists 1954
oil on canvas
392.2 x 372.9 cm

This enormous painting was commissioned from Fernand Léger by his friend Douglas Cooper, the well-known collector and historian of Cubism. Cooper ordered the painting for the stairwell of his mansion, the Château de Castille at Argilliers in the south of France. The subject of the painting was based on a lithograph of a group of trapeze artists which Léger had already published in a book, *Le Cirque*, which Cooper owned and liked. Given the large scale of the work, it may be that Léger employed assistants to help him with its execution. The broad poster style

of the work, the use of primary colour and the unshaded outline drawing of the figures give the painting its immediacy and freshness.

Pablo Picasso 1881–1973
Luncheon on the grass 1962
colour linocut from one block
53.0 x 64.1 cm (comp.);
69.9 x 75.2 cm (sheet)
© Pablo Picasso, 1962/Succession
Pablo Picasso. Reproduced by permission
of VI$COPY Ltd, Sydney 1997

In 1955, Pablo Picasso settled permanently in the south of France with no apparent desire to return to Paris. It was at this time that Picasso turned to making linocuts. It was a simpler method of working away from the major Parisian ateliers. The use of more modest tools and technique liberated Picasso and his art from a straitjacket of earlier styles and he could avoid the need to send proofs back and forth to Paris (which would have been the case for lithography or intaglio prints).

During nearly a three-year period from 1959–62 Picasso was so obsessed with Eduoard Manet's *Luncheon on the grass* of 1863 that he produced over 100 paintings, prints and drawings on this theme. In his homage to Manet (but with the clear intent of outclassing him), Picasso combines a joyous bucolic scene with resplendent female nudes, strongly sexual with their bold curvaceous forms and pronounced genitalia. Their male companions (significant in Manet's 19th century painting), take a back seat to the women. At the same time, Picasso revisits Cubism in this work, mixing an investigation of spatial arrangements with decorative elements in a composition rendered in brilliant acid colours.

The National Gallery is fortunate to own some key early prints and drawings, including the outstanding group of 100 intaglio prints from the 1930s known as the *Vollard Suite*.

Andy Warhol 1928–1987
Elvis 1963
synthetic polymer paint screenprinted
onto canvas
208.0 x 91.0 cm
© Andy Warhol, 1963/ARS. Reproduced
by permission of VI$COPY Ltd, Sydney 1997

From August 1962 Warhol began to produce pictures using the screen printing process. Working with the young poet Gerald Malanga, he developed a series of images of American icons: Campbell soup cans and Coke bottles, and celebrities such as

Marilyn Monroe and Elvis Presley. The image of the singer was taken from a publicity still for the film *Flaming Star* (1960).

Warhol is here subverting the cult of celebrity, making instead a witty statement about camp and kitsch. Elvis exists in various combinations: as five single images, six superimposed images and two diptychs. The other portrait works of this period — of Troy Donahue, Warren Beatty and Elizabeth Taylor — show heads only.

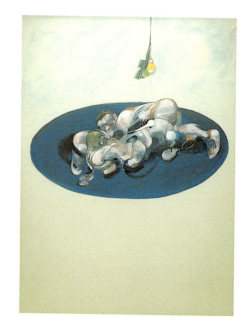
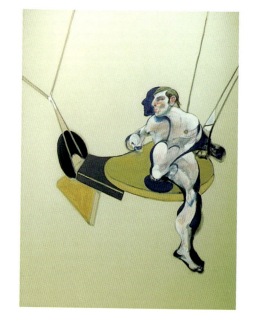

Francis Bacon 1909–1992
Triptych 1970
oil on canvas
each canvas 198.0 x 147.5 cm
© Francis Bacon Estate, 1998

Francis Bacon has taken the three
panel format of religious painting
to create heightened personal
narratives. The figure on each side
of the composition — clothed
on the left panel and naked on the
right — is George Dyer, Bacon's
close friend and primary model.
The tension between the two
extremes is not resolved in the
central panel which shows two
wrestling figures. The single,
dangling light bulb above the
figures conveys an atmosphere
of desperation and isolation.
The image, taken from a
photograph by Eadweard
Muybridge is somehow erotic and
dangerous at the same time.

Bacon preferred to work from
photographs and memory rather
than from life. His figures are
distorted and located in ill-defined
spaces — he simultaneously
evokes the ambiguity of dream and
the sharp focus of conflict and
tension.

Cindy Sherman b.1954
Untitled no.93 1981
type C colour photograph
61.5 x 123.0 cm
Courtesy of the artist and Metro Pictures

Until recently the solitary character
in Cindy Sherman's photographic
tableaux has been the artist herself
elaborately costumed and located
within a set which gave some clues
to the charades. However, some
300 works made by Sherman since
1976 are all untitled and not
autobiographical in intent.
Her cast of different characters
are not role models for young
feminists but often passive
stereotypes familiar from films
and popular culture.

Untitled no.93 has a tousled
Hollywood blonde grasping sheets
to her chest in a classic gesture

of protection or penitence; what
appears to be dawn light breaks
on her face. It seems to be the
metaphorical 'morning-after-the-
night-before' picture and one
which has an echo of the highly
detailed 19th century story-telling
paintings on the theme of the
fallen woman's awakened
conscience. Sherman rarely speaks
about the meaning of the works
but has said that the woman here
is not a victim of anything other
than her own actions. Sherman's
images remain ambiguous but
raise questions of their own
as valid as those in documentary
photography.

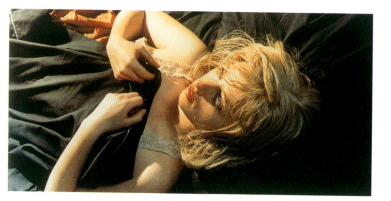

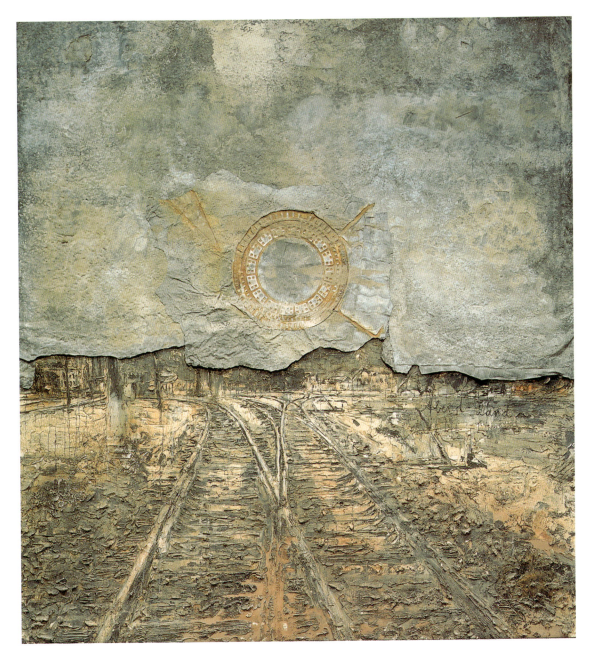

Anselm Kiefer b.1945
Twilight of the West 1989
lead sheet, synthetic polymer paint,
ash, plaster, cement, earth, varnish
on canvas and wood
400.0 x 380.0 x 12.0 cm

Twilight of the West owes much
of its strength to the juxtaposition
of its materials. The painting
is divided, almost in half. The
upper section consists of three
pieces of impressed lead —
wrinkled, marked, oxidised —
making a dramatic contrast against
the lower section's thick impasto

of paint, ash and cement. Like the
lead curtain, the landscape below
is nearly monochromatic. The
limited range of colour reproduces
the muting effect of twilight,
suggesting a present violated
by the past.

The title of the work derives
from the philosopher Oswald
Spengler's study *Der Untergang des
Abendlandes* (*The Decline of the
West*), first published in 1918.
The painting refers to the
weariness and moral
disillusionment of our strife-torn
century, and to the notion that

Western societies must begin
to pay the price for their economic
and political supremacy. Anselm
Kiefer's themes of myth and
history take on a sense of theatre
at this scale.

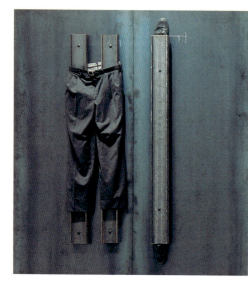 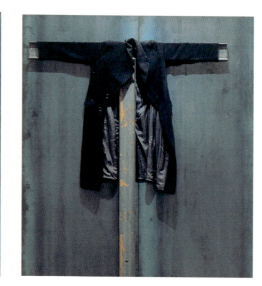 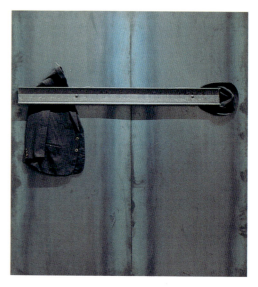

Jannis Kounellis b.1936
Untitled 1990
steel panels and beams, clothes
200.0 x 574.0 x 25.0 cm (installation);
200.0 x 181.0 x 25.0 cm (each panel)

Beautiful and repellent, *Untitled*
(1990) by Jannis Kounellis
contrasts the gunmetal sheen
of industrial steel with the textured
and comforting surfaces of wool,
felt and leather. In the formal
relationships between its elements,
this work retains the elegant clarity
and strength of Minimal art;
however, the symbolic junction
of the materials provides the motor
for creating a complex and poetic
narrative. The coupling of brutally
strong and fragile elements

informs our reading of the
composition, as does as our
knowledge of their practical use.
The physicality of these forms
makes us think of the outside
world and also, by contrast,
of the inner self. The artist
connects the rise of technology
to the oppressiveness of urban
existence and a loss of faith,
but his *Untitled* also expresses
a passionate joining with the
world. Kounellis acknowledges
the *eros* and *thanatos* of crucifixion
iconography: there is tenderness
and vulnerability in this
identification.

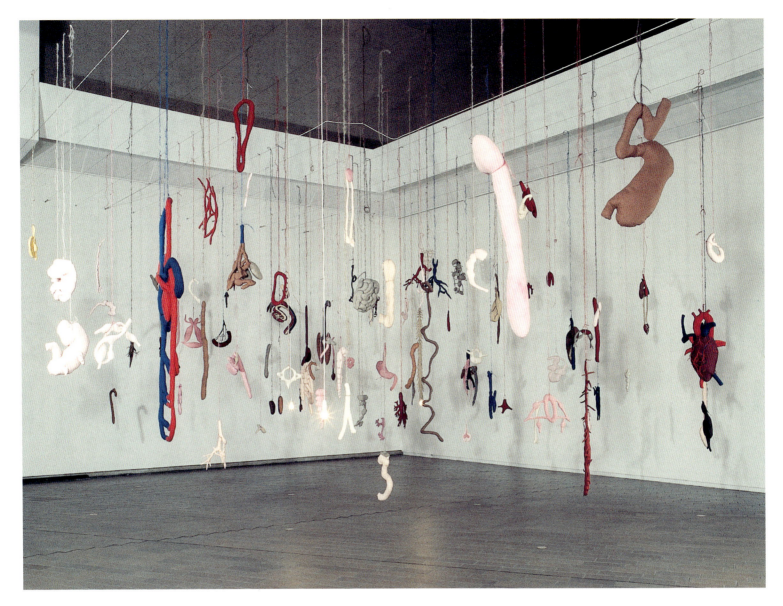

Annette Messager b.1943
Penetration 1993–94
50 sewn and stuffed fabric elements
© Annette Messager, 1993–94/ADAGP.
Reproduced by permission of VI$COPY Ltd,
Sydney 1997

Penetration is an installation
of colourful fabrics sewn together
and stuffed to form intestines,
hearts, lungs, spines and other
internal organs. Fifty of these
forms are suspended by woolen
yarn from the ceiling in a regular
grid. The effect is playful rather
than visceral, and while there is
something of the butcher shop, the
livers, kidneys and hearts hang like
appealing Christmas decorations.

Feminine vulnerability is
reflected in this installation, not
only in the title with all its sexual
overtones, but also in the presence
of the doll-like foetuses amongst
the other pendents. Both the loss
through miscarriage or abortion
and the generative power of the
female body are here. The body
also proclaims its sexuality in its
facture: bright fabrics, stitched
and stuffed in a joyous display
of traditional female skills.
Messager's work *is* sexualised and
indeed curiously sexy. *Penetration*
is a profound work, a serious
seduction that rewards the interest
of the viewer.

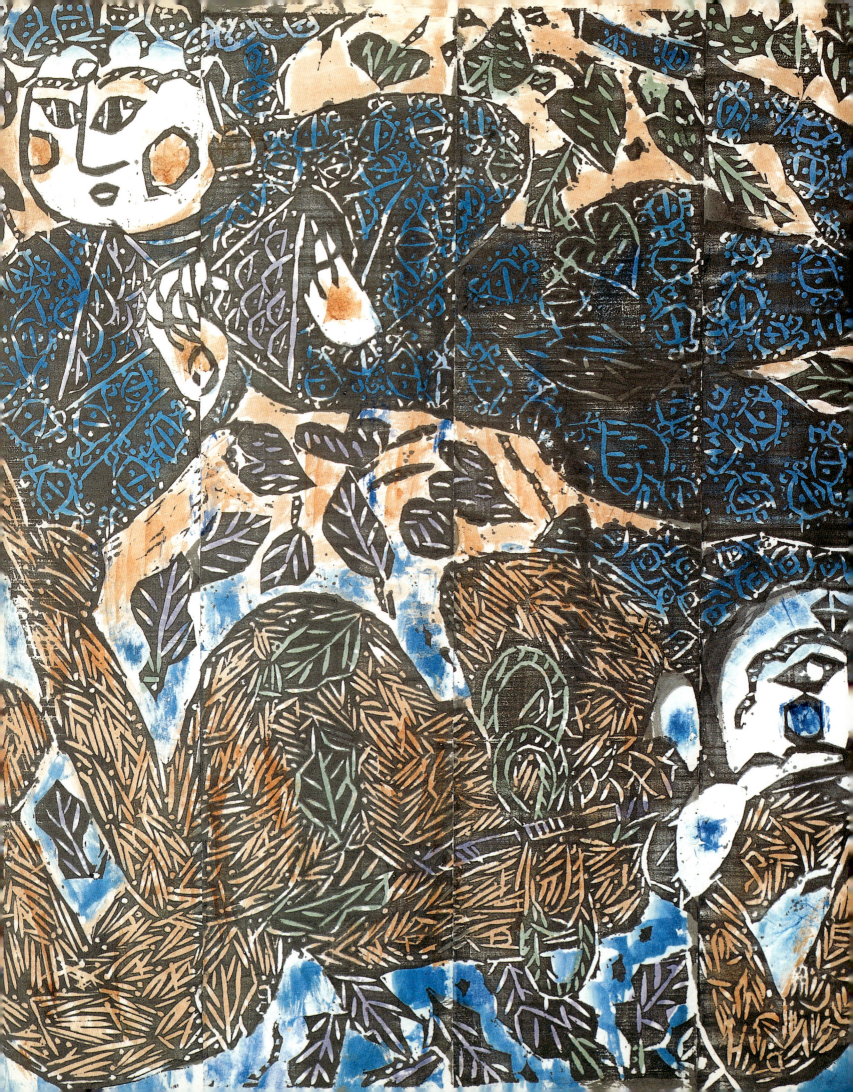

ASIAN ART

The arts of Asia are enormously varied. Demonstrating the creative skills of Asian artists past and present, works of Asian art in the collection range from Neolithic and early metal age ceramics from Iran, Japan, Thailand and China, to installations created in the 1990s by Montien Boonma from Thailand and Yukinori Yanagi from Japan.

The great variety in materials used in the creation of traditional art across Asian regions is reflected, for example, in Buddhist sculpture. Among these are Chinese earthenware objects from the Tang dynasty, such as the temple tile of a ferocious guardian figure; Japanese lacquered wooden and plaster images, exemplified by the prayerful Prince Shotoku; ornate gilded metal forms, as seen in the figure of the Nepalese saviour-deity Avalokiteshvara; stone works from south Asia, such as the intricate stupa gable from early Pakistan; and lost wax cast bronzes of India and South-East Asia illustrated by the Buddha 'calling the earth to witness', from the Lan Na kingdom of northern Thailand.

Great contrasts are also evident within the works of one medium. In Buddhist wooden sculpture, for example, the minimal rough-cut lines of the 16th century work of Japanese Zen priest Enku are very different from the smooth curves of the Pagan period temple image from Myanmar (Burma) of the Buddha sheltering under the coils of the serpent-king.

Religious works of art are found in every media. The collection contains significant Hindu sculpture, including the great stone Vishnu from the Pala dynasty of Bangladesh, the charming and accessible bronze elephant-headed god Ganesha, and the dynamic dancing figure of the god Shiva from the great bronze artists of the southern Indian Chola dynasty. Religious art also encompasses textiles and paintings which often are interchangeable in ceremonial use. Hangings and canopies illustrating the deities in Indra's heaven, Krishna charming the cowherders with his flute music, and temple scenes appearing on sacred textiles offered as gifts to the gods are important works in the Gallery's Asian art collection.

A rare group of Balinese manuscripts confirm the importance of Indian classical literature — such as the Ramayana and the Mahabharata epics for South-East Asian artists — while also demonstrating the 19th century shift in media from palm leaf to paper. The Asian collection also contains a range of paintings originally intended as illustrations for albums and manuscripts. Miniature paintings from India encompass the many great religious and philosophical traditions of south Asia — Jain, Hindu, Mughal, Sikh and the nationalist schools of the 20th century. A significant proportion of these works came as a gift to the people of Australia from the Gayer-Anderson brothers.

Like the Indian miniatures, other works on paper, particularly from regions with a long history of woodblock prints, illustrate both religious and secular themes. While the great 20th century Japanese graphic artist Munakata worked with traditional Buddhist imagery, a significant collection of *ukiyo-e* prints illustrate the secular interests and pastimes of town dwellers during the Edo and early Meiji periods of Japanese history. These works include evocative prints of flowers and seasons, images of beautiful courtesans and famous actors, and depictions of famous battles and scenes from legends. The Gallery's rare collection of 20th century Chinese woodcuts, however, contains primarily political works, created in the 1930s and 1940s in support of the radical social movements of the time.

The prints are in sharp contrast to the Gallery's small group of east Asian scrolls, which includes a formal landscape by the Chinese literati painter Lan Ying (1585–1669), Japanese images of the Shaka Buddha and his protectors and a portrait of the monk Daruma.

The majority of Chinese works in the Asian collection are funerary goods: earthenware sculptural pottery in a variety of forms — horses and camels, riders on horseback, and human figures engaged in courtly pursuits — created for burial in the tombs of great noble rulers. These works date from as early as the first century AD through to the Tang dynasty, when trade routes to Central Asia brought exotic arts and foreign forms to the vibrant Chinese court. They comprise the core of the gift from Hong Kong based entrepreneur T.T. Tsui.

Other works which are derived from trade are the vibrantly patterned costumes and richly embroidered accessories from the oasis towns of the old Silk Routes between China and the West. So, too, are the Indian textiles, which formed a crucial link in the spice trade between South-East Asia and the rest of the world. Wide-ranging in design — some Indian, many specifically designed to South-East Asian specifications, others part of the European taste in Chinoiserie — these impressive cottons and silks had enormous impact on Asian textile patterns, especially on Indonesian batik. The great workshops based on the island of Java also produced an amazing variety of designs for the local royal courts and for trade to far-flung regions. Each region created works in distinctive colours and patterns, which is reflected in the Gallery's large South-East Asian textile collection.

Textiles were invariably the work of women, and as such formed an integral aspect of the ceremonial and religious cycle. Without the dual arts of women and men — cool, soft textiles and hard, hot metalwork — the well-being and prosperity of community and family, of village and palace, could not be ensured. The male arts of South-East Asian ancestral beliefs — sculptural objects in metal, stone and wood — are also represented in the collection, and include grotesque mask designs to scare evil spirits, and impressive gold pendants which counterbalance textiles in the ceremonial exchanges accompanying clan marriages. Like the Lake Sentani house post and the Sumba gold *mamuli* treasure, and many of the textiles, the objects symbolically incorporate the underlying duality of male and female.

The collection of Asian art encompasses the diversity of media and meaning that can be found over time in the arts of Asian regions. Some aspects are represented by a single outstanding example. Other art forms, particularly those of more fragile media that are unable to remain on permanent display, have been collected in more depth to demonstrate the enormous variety of subject, technique and style to be found in Asian art. Working within the constraints of traditional art style, each artist has created a unique masterpiece of Asian art.

Lake Sentani region
Irian Jaya, Indonesia
Double figure from a house post
18th century
wood
177.2 x 49.2 x 19.1 cm

Lake Sentani is an enormous inland sea located near the north coast of Irian Jaya close to the border of Papua New Guinea. The communities living on its banks constructed huge communal dwellings and ceremonial houses supported above the waters of the lake on tall wooden piles. The tops of many of the posts were carved so that the sculptures protruded through the floor into the living quarters above. Posts were also erected outside the houses, sometimes forming part of the jetties and bridges between the dwellings and the bank of the lake. Many of the carvings were of human forms, like this large post depicting a pair of male and female figures. Discovered submerged in the lake, the post might have formed part of a chieftain's house.

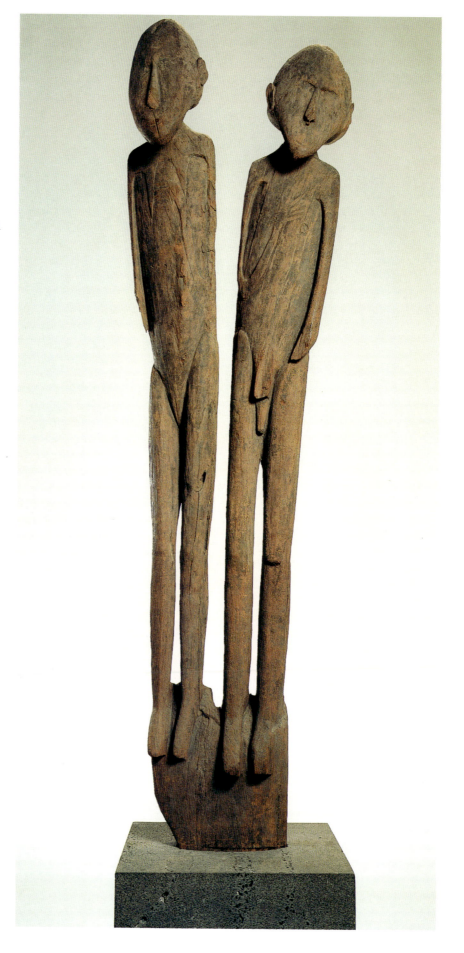

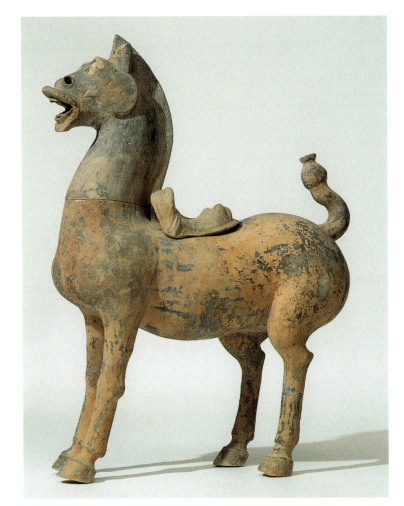

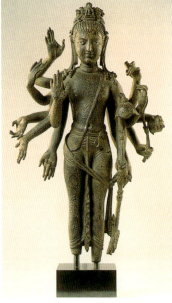

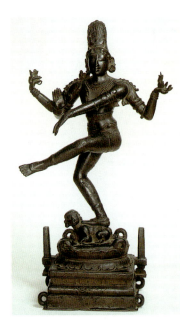

Eastern Han dynasty
Sichuan province, China
Standing horse 25–220 AD
painted grey ceramic
height 84.0 cm
Gift to the National Collection of Asian Art
from Dr T.T. Tsui, JP, Hong Kong, through
the National Gallery of Australia Foundation

During the Han dynasty
(206 BC – 220 AD) nobles lavishly
furnished their tombs with ceramic
miniatures of their houses, servants
and animals, symbols of worldly
power and wealth. This unusually
large mortuary figure is related
to ceramic and bronze horses
excavated from cliff-side tombs in
Sichuan province in Central China.
It represents a central Asian breed
of horse, imported into China
in preference to the smaller
domestic Mongolian ponies. Known
as 'celestial horses', these powerful

creatures provided a popular set
of images for Chinese art.

This horse, like many large tomb
figures, was constructed by piecing
together a number of separately
moulded segments, many of which
were also painted. The alert
expression of this horse is indicative
of a prized royal beast.

North-western region India
The bodhisattva Avalokiteshvara c.700
cast bronze with silver inlay
height 50.0 cm

In Buddhism, a bodhisattva
is a being able to achieve
Enlightenment, but who delays the
attainment of Buddhahood in order
to help others. Avalokiteshvara is the
most popular bodhisattva, widely
worshipped for his compassion.
This rare 12-armed bronze figure
of the saviour is depicted as a
wandering ascetic, in a rigid pose
with his hair gathered up into a
crown of matted locks and without
the usual elaborate jewellery. Above
his forehead is a small image of
a seated Buddha.

The bodhisattva's 12 hands
display his various qualities in
symbolic form. One hand holds
an ascetic's water pot while others
hold a pendant lotus, a flame,
a small fruit, a jewel and a small
palm leaf manuscript. Other hands
display gestures, such as those
of reassurance and charity.

Chola dynasty
Tamil Nadu, India
*Shiva as Nataraja [The Lord of the
Dance]* second half of 10th century
bronze, lost wax technique
86.0 x 48.0 x 24.5 cm

Shiva is one of the most important
gods of the Hindu religion.
He is regarded as the creator and
the destroyer of the universe,
representing the continual cycle
of death and rebirth which is a
fundamental tenet of Hindu
philosophy.

This cast copper image of Shiva
in the form of Nataraja shows the
deity performing the Dance of Bliss.
According to Hindu belief, during
the dance Shiva carries out the five
acts necessary for the continuation of
the life cycle — creation, protection,
the dispelling of ignorance, the
granting of solace, and destruction.
Each element is represented by
particular hand and leg positions
together with symbols such as the
flame, which symbolises destruction.
A missing circle of flames would
have surrounded Shiva.

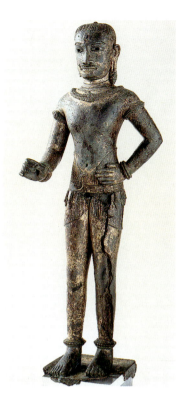

Angkor period (Baphuon style)
Cambodia
Shiva c.1010–50
bronze, lost wax casting, with silver
and glass inlay, gold leaf, gilding
height 50.0 cm

Hinduism was the predominant
religion of the Khmer people
of Cambodia from the early
centuries AD until the 13th
century. This image of the great
Hindu god, Shiva, was hollow
cast in bronze and then gilded.
It displays the elegant proportions
and refined craftsmanship
characteristic of the Baphuon style
of Khmer art (1010–80). The eyes,
including the third eye on the
forehead, eyebrows and moustache
are all inlaid with black glass and
silver. Shiva wears a traditional
Cambodian pleated wrap with
a jewelled belt, and a tight-fitting
cap decorated with alternating
bands of flowers and beads.
An inscription around the base
indicates that the image was
commissioned for a temple by
Queen Viralakshmi, wife of King
Suryavarman I (r.1002–50).

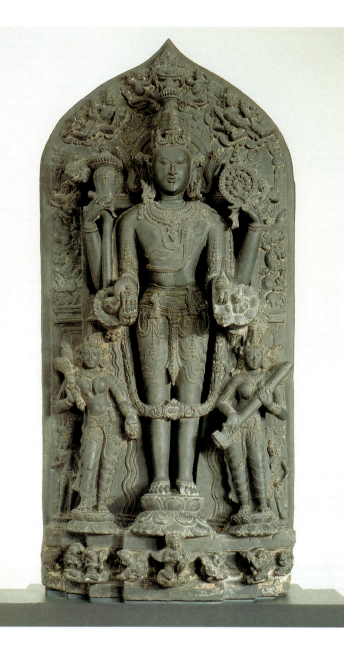

Pala dynasty
Shialdi, Dhaka district, Bangladesh
Vishnu in the form of Trivikrama
early 12th century
black phyllite stone
height 162.5 cm

The Hindu gods are often shown
with more than two arms; their
additional hands usually carry
symbolic objects or make symbolic
gestures. Here the great Hindu
god, Vishnu, is depicted as
Trivikrama, the solar god who
crosses the sky each day with
'three great strides'. He holds
a *chakra* (a discus-shaped

weapon that represents earthly and
cosmic order), a battle mace and
a conch shell. His fourth hand
is shown in a gesture of charity.
He is flanked by the goddesses
Lakshmi (holding a fly-whisk)
and Sarasvati (playing a musical
instrument called a *vina*).

This image would most likely
have been installed in the main
shrine of a Hindu temple as the
principal focus of worship. The
eyes are the last feature of a Hindu
image to be sculpted and become
the focus of the consecration
ceremony in which they are
'opened' with a golden needle.

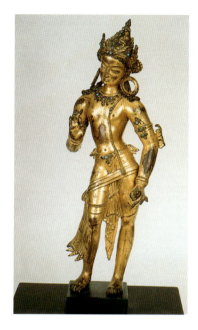

Early Malla period (1200–1482)
Kathmandu valley, Nepal
The bodhisattva Avalokiteshvara
13th century
copper, gold leaf, semiprecious
stones, lost wax casting, gilding
height 47.3 cm

This is an image of the popular
Buddhist saviour, the bodhisattva
Avalokiteshvara, who delayed his
own achievement of nirvana to help
other mortals towards the Buddhist
goal of Enlightenment. As in this
sumptuous gilt copper image, he
is often portrayed as a lithe youth,
standing in a graceful triple-bend
pose. His left hand would have
clasped the stem of a lotus while
his right hand shows the gesture
of discourse or argument.

The cult of the all-conquering
bodhisattva Avalokiteshvara spread
from India across Asia, rivalling
that of the Buddha Shakyamuni,
especially in regions such as Nepal
where the Vajrayana form of
Buddhism was practised.

The Early Malla period was
an age of great artistic
achievements in Nepal, as artists
produced both Buddhist imagery
for the temples and monasteries,
and Hindu sculpture for the
Hindu royal courts.

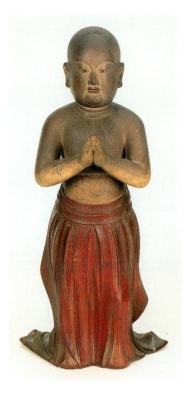

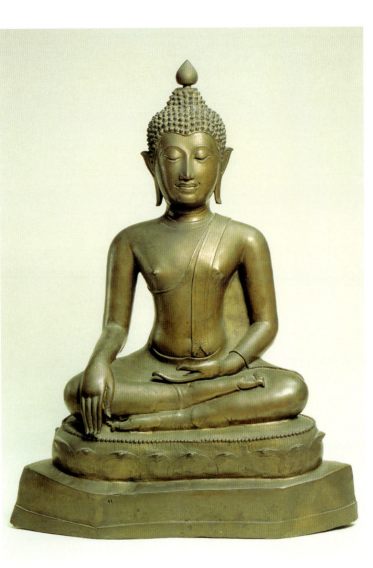

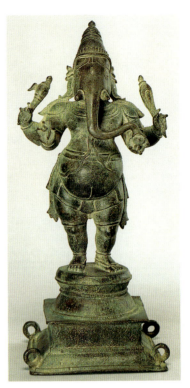

Kamakura period
Japan
Prince Shotoku praying to the Buddha
*c.*1300
wood, lacquer, gesso, paint
height 48.2 cm

Although, by choice, he never
ruled in his own name, Prince
Shotoku (574–622) is remembered
as the founding father of the
Japanese state and as an ideal
Buddhist king. People began
to worship the prince soon after
his death in 622, however his cult
was particularly strong in the
Kamakura period (1185–1392).

This sculpture shows Prince
Shotoku at the age of two when,
on the anniversary of the Buddha's
death, he faced east, placed his
palms together and prayed
'Hail! Buddha!'. When he parted
his hands they held a relic of the
Buddha. This image is probably
hollow, with with a small inner
chamber containing a fragment
of Buddhist text. The realism with
which the young prince is depicted
is characteristic of the
Kamakura period.

Lan Na period
Northern Thailand
The Buddha 'calling the earth to
witness' 15th century
cast bronze
height 67.0 cm

The kings of Lan Na who ruled
over much of northern Thailand
from the late 13th century to the
16th century were followers of
Theravada Buddhism. This image
of the Buddha reveals the
distinctive features of the Lan Na
style — the broad shoulders and
chest tapering to a slim waist,
the oval face with arched eyebrows,
and the *ushnisha* (the protuberance
from the top of the head) in the
shape of a lotus bud. This popular
depiction of the Buddha 'calling

the earth to witness' represents the
final test faced by Prince Gautama
on the eve of his Enlightenment
after which he became the
Buddha. Mara, the god of desire
and death, challenged Gautama
who replied by extending his right
arm to the earth. In response,
the earth goddess rose up and,
wringing water from her long hair,
washed away Mara and his armies.

Vijayanagar period
Tamil Nadu, India
Ganesha 15th–16th century
bronze, lost wax casting
height 41.0 cm

Among the pantheon of deities
associated with Hinduism, the
elephant-headed god Ganesha
is one of the most popular.
However, few temples are
dedicated solely to this son of the
great god Shiva and his consort,
the goddess Parvati, although
images of Ganesha appear in
doorways and subsidiary shrines
of temples to other deities.

Usually depicted with several
arms, in this sculpture Ganesha
holds an elephant goad and a
noose in his upper hands. His
lower hands hold a bowl of sweets
that he devours with his trunk,
and the fragment of his own tusk.
Legend tells that Ganesha broke
off one of his tusks to throw at
the moon when it laughed at him.

This image was cast for temple
ceremony with lugs at the base
to insert carrying poles for
processions.

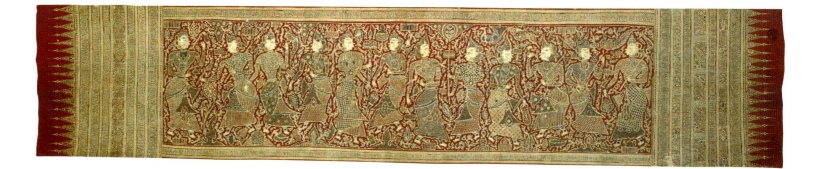

Mughal empire
Gujarat, India
Heirloom textile [ma'a] 1634, traded
in the 17th century to Sulawesi,
Indonesia
handspun cotton, natural dyes and
mordants, mordant painting, batik
102.0 x 534.0 cm
Gift of Michael and Mary Abbott

The trade in Indian cloth has been
crucial to the global history of
textiles. In Indonesia, Indian
textiles were, for a time, crucial
in barter exchanges for the
region's primary produce. This
textile was probably traded in the
mid 17th century through the busy
port of Makassar (now Ujung
Pandang) into the central
highlands of the island of
Sulawesi, where it has remained
in a family treasury for centuries.
Such cloths were only displayed
on ceremonial occasions
particularly at agricultural rites
which evoked fertility and
prosperity.

The designs on the trade
textiles varied enormously.
This rare early example is painted
in medieval Indian style with the
heads of each of the six pairs
of female courtiers shown in
profile with protruding eyes.

Choson dynasty (1392–1910)
Korea
*Korean Tribute Missions at the Chinese
Court* late 18th – early 19th century
ink and pigment on silk
150.0 x 357.0 cm
Gift of Rachel Reeve Human in memory
of her parents Charles and Jessie McLaren

This screen depicts one of the
major annual events on the Korean
court calendar during the Choson
dynasty (1392–1910). At the time
of the Chinese New Year
celebrations, all countries which
were either trading with China
or wished to access Chinese
territory, were required to pay
tribute to the emperor at the
imperial palace in Peking. The
representatives would present their
credentials along with a list of
their gifts to the court officials
before waiting in line to give their
presents to the emperor.

The scene shows the dignitaries
with their attendants and gifts
making their way through the
palace gates towards the emperor.
It is painted in the traditional
Choson court art style; the
perspective is deliberately
two-dimensional, the figures are
unemotional and the colour
palette restricted.

Garhwal or Kangra courts
Himachal Pradesh, India
The wedding of Krishna and Rukmini
c.1820
opaque watercolour and gold
on paper
35.6 x 49.6 cm (folio);
34.1 x 48.2 cm (painting)
Gift of Robert Skelton through the
Gayer-Anderson Gift

The lives of the Hindu gods are
commonly depicted in the arts
of the royal courts of India. Here,
in the flat, almost two-dimensional
style typical of paintings of this
region and period, three events
are set in a continuous story.
In the upper chamber Krishna, an
incarnation of Vishnu, has his hair
washed and dressed: an essential
pre-nuptial ritual. In the presence
of Krishna's earthly father,
Vasudeva, and other guests, King
Ugrasena casts an offering towards
the blue-skinned Krishna. In a
chamber on the lower left, Krishna's
betrothed, Rukmini, has her hair

anointed. In both scenes, priests
recite hymns from sacred texts.
The scene on the lower right again
depicts King Ugrasena, in pale

yellow, with Vasudeva, in mauve,
watching a dance performance
while court musicians are shown
the chamber in the upper left.

Hokusai Katsushika 1760–1849
Peonies and butterfly
from the series *Large Flowers* 1830–31
colour woodcut
25.0 x 37.4 cm

Hokusai was one of the most
important artists of Edo Japan, best
known for his series of landscape
prints *Thirty-Six Views of Mount Fuji*
(1828–33). He is also renowned
for his 'flower and bird' pictures
(*kacho-ga*), depictions of the natural
world in which a particular animal
or bird is grouped with a plant to
suggest a season or simply because
of their harmonious association.

Peonies and butterfly comes from
a series of 11 *Large Flowers* published
in 1830–31. It is notable for its
dramatic, cropped composition,
subtle colours, and exquisite
evocation of movement. A spring
breeze blows across a peony bush,
turning the leaves and blossoms,
making the butterfly tumble
in the wind. The artist's signature
appears in the lower left along with
a government censorship seal
of 1800–42.

Workshop of Sayyid Hussain Shah
and Sayyid Muhammad Mir Srinagar,
Kashmir, India
The Godfrey shawl c.1870
cashmere wool, natural dyes,
embroidery
208.0 x 185.0 cm
Gift of the Godfrey family

The superfine wool shawls from
Kashmir had long been highly
prized from India to the Middle
East. In response to market
pressures from Europe in the
19th century, intricate embroidery
was substituted for the original
tapestry weaving.

One of the rarest forms was
the map shawl, of which only four
are known to have existed. Each
displays a detailed map of the town
of Srinagar, the summer retreat
of the Mughal emperors and the
home of the famous shawl
workshops. Along the banks of the
Dal Lake and the Jhelum River are
the city's major landmarks, such
as the Mughal gardens and the
Maharaja's palace. This shawl was
purchased in 1896 from the State
Treasury of Jammu and Kashmir
by the grandfather of the donor,
Major Stuart Godfrey.

Buleleng palace (Puri Buleleng)
Singaraja, Bali, Indonesia
*The Burning of the God of Love
[Smara Dahana]* mid 19th century
palm-leaf manuscript, ink, pigments,
gold leaf, cord and Chinese coin,
wooden storage container, incising,
painting, gilding
5.3 x 49.5 cm

The oldest manuscripts in
South-East Asia were made from
the processed leaves of the
palmyra palm, with text and
drawings incised into the narrow
strips then rubbed with ink. This
rare 19th century work from the
royal court of Buleleng in northern
Bali is fully illustrated on both
sides of each leaf. Two leaves and
the storage box lid are highlighted
in pigments and gold leaf.

The Burning of the God of Love
is a long court poem, composed by
the Javanese poet Dharmaja during
the 12th century. It relates the fate
of Kama, the god of sensual love,
who tries to instil passion into the
heart of the great Hindu god Shiva
during his ascetic retreat on Mount
Meru. Eventually, when woken
from his yogic stance, Shiva angrily
incinerated Kama with a fiery
glance. Kama continued his quest
as a formless spirit.

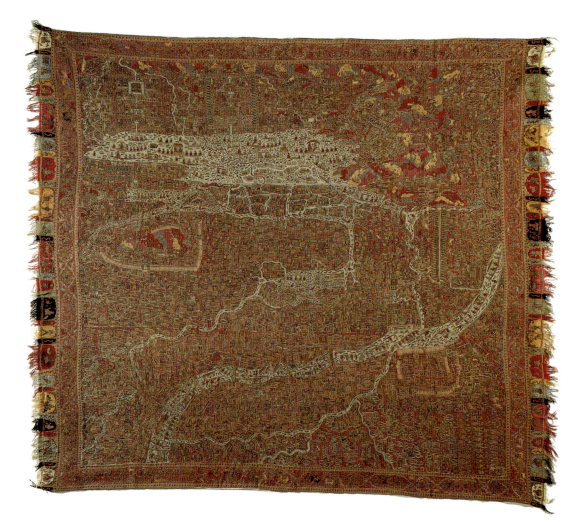

Kanatang domain
East Sumba, Indonesia
Ceremonial ear pendant [mamuli]
19th century
gold alloy
10.2 x 9.6 x 1.4 cm

Yoshitoshi Tsukioka 1839–1892
Ichikawa Danjuro IX (as Musashiro Benkei in Kanjincho) 1890
woodblock print
36.8 x 74.1 cm

In 12th century Japan two warrior families, the Taira and the Minamoto, struggled for the right to rule the country. The Taira were eventually victorious and installed their ruler, Yoritomo, as supreme military commander, or shogun. However Yoritomo felt threatened by his younger and more popular brother, Yoshitsune, and tried to have him assassinated. To escape, Yoshitsune and his followers fled north, disguised as monks. At one of the many checkpoints set up by his brother, Yoshitsune was stopped. To protect his master, one loyal follower — a giant of a man called Benkei — stepped forward and showed the officials documents proving that they were monks.

This dramatic story became a popular play of the kabuki theatre. In this print by the late *ukiyo-e* master, Yoshitoshi Tsukioka, the actor playing Benkei is depicted at this climactic moment.

Balinese people
Tenganan, Bali, Indonesia
Sacred textile [geringsing wayang kebo]
19th century
handspun cotton, gold thread, natural dyes, double ikat, embroidery
54.0 x 212.0 cm

The small Balinese walled village of Tenganan is one of only two places in the world where the double ikat weaving technique is used. This involves tying and dyeing of both the warp and the weft threads into designs before weaving commences. This ancient design shows groups of kneeling figures, reflecting scenes on temple reliefs.

The textiles, known as *geringsing*, are worn as ceremonial clothing in village rites. Perhaps because of their complexity, *geringsing* are considered to be the most magical and powerful of Balinese textiles, highly prized across the island for use in rituals such as toothfiling ceremonies, cremations, and as an important part of the offerings to the Hindu gods. Small fragments of cloth are burned to form magical cures for serious illnesses.

Gold objects are sacred heirlooms throughout outer-island Indonesia, where they are valued as ceremonial adornment, family wealth and marriage exchange commodities. On Sumba, the oldest and finest items of ancestral jewellery are considered holy objects embodying the essence of the great families, hidden in the peaked attics of the great clan houses, and brought out only on important ritual occasions when they are worn by both men and women.

Along the base of this fine example, figures of male warriors represent the wealth and power of the men who give *mamuli* to their prospective bride's family. Its omega shape represents the female. Thus, the pendant symbolises the body of the bride, the counter-gift for her fertility which is given away by her noble family at marriage.

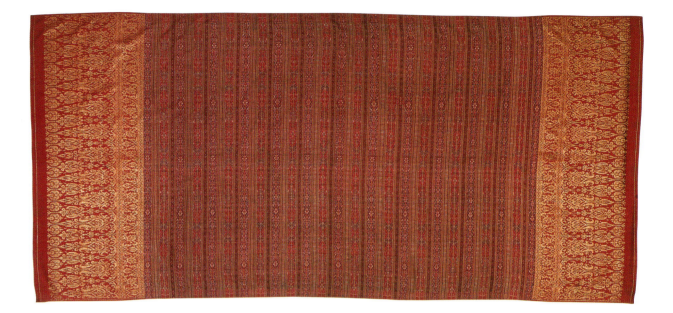

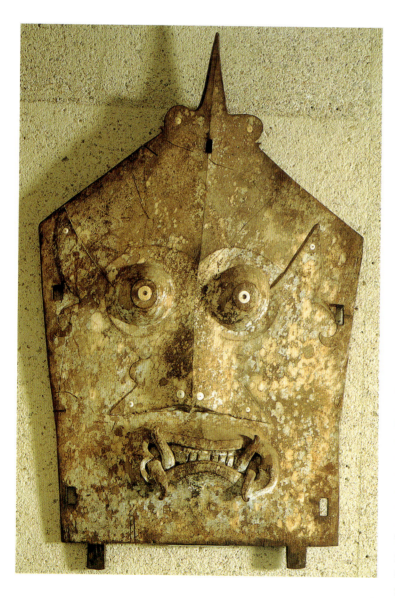

Modang people
Central Kalimantan, Indonesia
Panel of a funerary vault [salong]
19th century
wood, conus shells
height 169.0 cm

Throughout the remote inland regions and isolated islands of South-East Asia, ancestral religious traditions have survived well into the 20th century. Combining the veneration of ancestors with beliefs in spirits of nature, the major religious and social events usually focus on the continuing prosperity of the community. The successful journey of the deceased's spirit into the afterworld is one of the most important ways of ensuring ongoing good fortune. To this end, funeral rites to honour the dead are elaborate. Amongst the Modang, where social hierarchy is very important, large mausoleums (*salong*) are constructed to store the bones of deceased aristocrats that have been exhumed and cleaned during secondary burial celebrations. This heavy pentagon-shaped panel formed the end wall of the funerary vault. The menacing face is intended to ward off evil spirits.

Malay people
Terengganu, Malaysia
Ceremonial stole [kain selendang songket lemar] 19th century
silk, gold-wrapped thread, natural dyes, weft ikat, supplementary weft weaving
206.0 x 103.0 cm

The wearing of textiles in gold-wrapped thread and expensive imported silk was restricted to the members of the aristocracy throughout insular and mainland South-East Asia. The textiles were symbols of power and high rank associated with state ceremonies. Royal weddings and circumcisions were also occasions for spectacular displays of cloth, both as costume and furnishings. Many textiles can be worn by either sex, provided the wearer is of sufficient rank.

In the Islamic Malay court of Terengganu on the eastern coast of the Malay peninsula, designs were largely floral and geometric, often with poetic titles. On this shoulder cloth, wide golden borders of bamboo shoots enclose the banded ikat field.

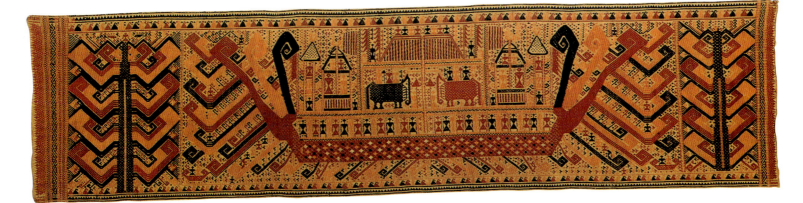

Paminggir people
Kalianda district, Lampung province,
Sumatra, Indonesia
Ceremonial hanging with ship design
[palepai] 19th century
handspun cotton, natural dyes, gold
ribbon, supplementary weft weaving,
applique,
68.0 x 280.3 cm
Purchased with the assistance
of James Mollison

The ship is a powerful symbol
of transition in many parts of
Indonesia. It is displayed at many
rites associated with change
of status such as birth,
circumcisions, toothfilings at the
onset of adulthood, weddings,
and perhaps most importantly at
funerals when the soul of the
deceased moves on to the next
world. For Paminggir nobility
who control the large *palepai* ship
cloths, the presence of these
prestigious textiles was essential
at ceremonies pronouncing the
rank of the local ruler.

On this rare single red ship
cloth, the central feature is a large
sailing vessel with curving prows,
flanked by stylised tree images.
Its decks are filled with passengers
and crew. Aristocratic status
is indicated by parasols of honour,
and the pair of huge elephants.

Tai Daeng [Red Tai] people
Hua Phan province, Laos
Funeral shroud or banner
[pa vien rong] 19th century
silk, cotton, natural dyes,
supplementary weft weaving
440.0 x 22.5 cm (detail)

Each of the many Tai- or
Lao-speaking communities
of mainland South-East Asia has
developed a distinctive design
or style for its traditional textiles.
Among the Tai peoples living
in the border regions where
northern Laos, China and
Vietnam meet, the long, narrow
ceremonial banners — up to eight
metres long — always display
designs of good omen.
Cloths such as these were most
prominently displayed at funerals,
especially as coffin covers —
the term *pa vien rong* means cloth
around a coffin.

In the more remote regions,
mythical animals and birds, often
with human figures as riders,
are woven into textiles. Since the
worship of ancestors is an
important part of funeral rites,
it is possible that the large motifs
found on this design, with their
long ear-lobes and five-fingered
hands represent deities or
important ancestors.

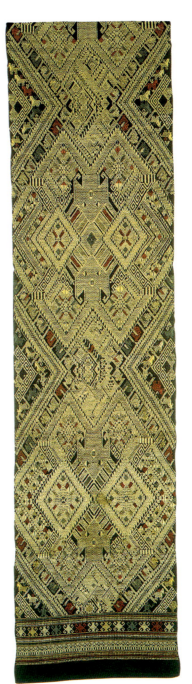

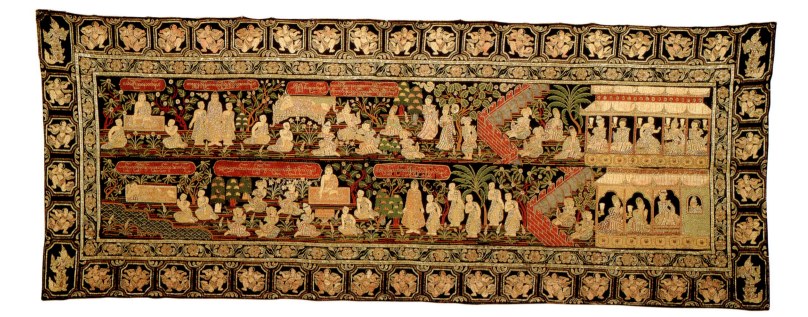

Burmese people
Taunggyi, Amarapura district,
Myanmar (Burma)
Religious hanging [kalaga] 1911
cotton, woollen flannel, silk, paper,
sequins, semiprecious stones,
embroidery, applique, painting
165.0 x 442.0 cm

This richly appliqued and
embroidered hanging shows
scenes from the earthly life of the
Buddha. In keeping with Burmese
tradition, the Buddha Shakyamuni
is depicted flanked by his chief
disciples, Sariputta and
Moggallana. The scenes include
the Buddha as Prince Siddartha
(his title before he renounced his
royal status), the Buddha
preaching and on his death bed.

In the Buddhist world of
South-East Asia, textiles play an
important ceremonial role. They
are often given to monasteries in
the religious act of attaining merit
and are usually embellished with
an inscription naming the donor.
Here, the embroidered script in
couched gold thread indicates it
was intended as a donation from
Ko Sein of Taunggyi to a Buddhist
monastery in the Burmese year
1273 (1911 AD).

Uzbek people
Bukhara, Uzbekistan
Woman's robe [khalat] c.1910
silk, natural dyes, printed cotton
lining, warp ikat, tablet weaving
133.2 x 177.3 cm

The Central Asian region of
today's Uzbekistan lay on the
famed Silk Road between China
and the West. The sultanates
or khanates that arose in the great
trading towns of Bukhara and
Samarqand displayed their wealth
in handsome apparel and rich
furnishings. Fine textiles were
produced in the many specialised
craft guilds that developed in these
urban centres.

For centuries, the boldly
patterned silk robes of the
townspeople, largely Uzbeks, have
been an important feature of
ceremony, and for the very wealthy
and powerful, of everyday wear
for all ages. Robes and coats of
various cuts are worn by both men
and women. While the tailoring is
simple, the colours are rich and
luminous and the designs bold
and abstract. This design is based
on a bejewelled pendant.

compass points traditionally hung horizontally on the ceiling to protect a house or temple. Munakata places the gods above one another, in opposing positions, each prone figure supplied with a musical instrument.

Always an experimenter, Munakata used different colour combinations over the same printed image, applying his colours from the back, so that they would bleed through the paper to form subtle smudged areas. The works are simultaneously rough and smooth like wood, opaque and transparent like paper, bold and tender like his ink and colours.

Ding Zhengxian b.1914
Rural summer — Irrigation
from the set *Four Seasons in the Countryside* 1943
colour woodcut
16.0 x 12.3 cm
From the Peter Townsend Collection, purchased with the assistance of the Australia–China Council

In China during the 1930s and 1940s, radical artists responded to the Communist Party's call for a new visual language to speak to the masses. Woodcuts were ideal for this purpose. Made from cheap materials — ink, paper and wood — they could be displayed anywhere. While printing, an ancient Chinese invention, had long been used to make colourful festive decorations, Ding himself trained at writer Lu Xun's academy in Yan'an where European expressionist prints and a visiting Japanese print maker served as models for new woodcut techniques. In keeping with Communist priorities, Ding's

series traces the ageless cycle of rural harvests showing farmers cooperating to irrigate their crops in summer. Ding delights in the circular rhythms of the hats and the irrigation pools. He sets the warm yellows and browns of the earth against the clear light blue of water and a cloudless sky.

Munakata Shiko 1903–1975
Guardians of east and west
from the set *Four gods — Woodcuts for the Ceiling* 1953
hand-coloured woodcut
105.2 x 100.2 cm

Munakata is one of the great graphic artists of the 20th century. Incorporating Zen concepts allowed Munakata to combine spontaneity and a sense of joyous discovery with stories and images familiar from the canons of Buddhism or Daoism. In this scroll, one of a pair, the artist depicts guardian figures, spirits or gods of the winds and the

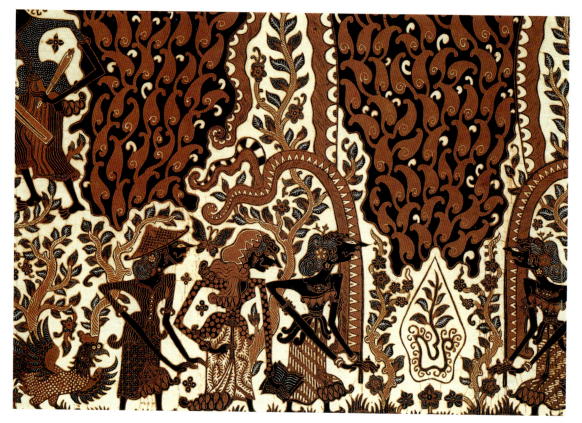

Fujiko Nakaya b.1938
Fog sculpture 1976
water vapour

Conceived for the 1976 Biennale of Sydney, this work was permanently installed in the National Gallery of Australia's extensive sculpture garden in 1982 for the Gallery's official opening. The artist has used a network of pipe and spray nozzles to create an ephemeral sculpture from the artificial fog of water vapour, which at certain times of the day drifts across the nearby pond.

In many ways this work challenges preconceived notions of sculpture. It is horizontal rather than vertical, it is moving not still, it is constantly changing with breezes and with the movement of people walking on the gravel path through it, and it disappears when the water is turned off.

Also pictured is Robert Stackhouse's *On the beach again* (1984).

Mohamad Hadi 1916–1983
Srikandi as Goddess of the Indonesian Women's Movement [Srikandi Gerwani] 1964 (detail)
cotton, natural dyes, batik
106.0 x 251.5 cm

The designer of this skirt cloth, Mohamad Hadi, was a member of the left-wing Institute of People's Culture (Lekra), a body of artists who rejected the domination of Western influences in Indonesian culture. Hadi attempted to imbue the traditional Indonesian textile technique of batik with a contemporary political message for the common people. Using the flat elongated shadow puppet form to depict human figures, he shows the warrior goddess Srikandi in a range of women's costumes representing a cross-section of Indonesian society — peasant, aristocratic and Islamic. The title links these idyllic images to the Indonesian Women's Movement, an organisation active in rural reform although banned after the change of regime in 1966. Despite Hadi's pioneering efforts, fine hand-drawn batik remained associated with the elite.

Montien Boonma b.1953
Temple of the mind: Sala for the mind
1995
wood, brass bells, medicinal herbs
300.0 x 200.0 (diameter)

The work of one of Thailand's leading contemporary artists, Montien Boonma, straddles the past and present, the materialism of the modern world and the other-worldliness of the Buddhist realm. Although the artist studied in France and has travelled and exhibited extensively outside South-East Asia, his work is infused with a distinctive regional quality.

In *Temple of the mind: Sala for the mind* (1995) Montien refers to the tradition of Hindu and Buddist priests salving not only the body but also the soul. The aromatic medicinal herbs painted on the surface of the sculpture symbolise this intention to sustain physical well-being. The privacy of the enclosed space in the sculpture encourages meditation on the fragility of the body and, ultimately, of the human spirit.

This work's tower structure takes the form of a Buddhist stupa. It is, however, not the solid traditional form, but an impermanent installation of flimsy packing cases supporting a carillon of 18 brass bells. The work is further imbued with the tradition in the form of medicinal herbs smeared on the surfaces of the component parts, whose colour and aroma pervade the sculpture and the surrounding space. The privacy of the accessible central cavity encourages meditation.

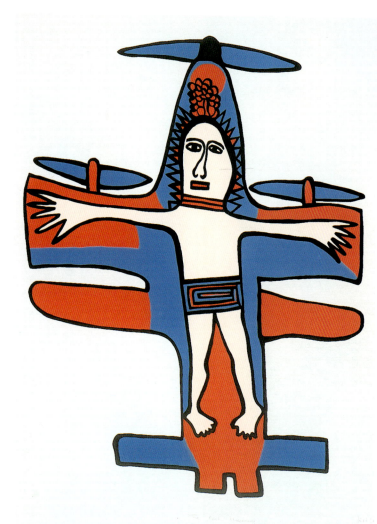

Mathius Kauage b.1944
The first missionary c.1976
paper, inks, screenprint
62.0 x 47.5 cm
Gordon Darling Fund

Mathius Kauage was a leader of the modernist art movement in Papua New Guinea. His early work deals with the relationship between men and machines and his early village life. Applying the modern medium of the screenprint, Kauage documents the arrival of the first white missionary to his home town of Simbu.

In this highland district, initiation ceremonies for young men involve flutes that symbolise sacred birds. Kauage links this indigenous symbolism to the image of the first missionary arriving by aeroplane, seen as a visit from a big bird. During Kauage's short attendance at a missionary school, his imagination was fired by his teacher's drawings of machinery; this work combines a range of influences with the cruciform shape of the plane echoed by the position of the Christ-like figure within.

Ambum Valley, Western Highlands, Papua New Guinea
The Ambum stone c.2000 BC ?
igneous rock
19.8 x 14.0 x 7.5 cm

This sculpture was discovered in 1962 in a cave in the Ambum Valley in the Western Highlands of Papua New Guinea. It was found with some 100 stone objects of which this is the most intricately carved.

The sculpture's antiquity is not known precisely; it is likely to be some 4000 years old, in which case it would be contemporaneous with the National Gallery's stone Goulandris idol from Greece.

The shape of the sculpture has been likened to the embryonic forms of the flying fox or anteater, both of which are found in the highlands of New Guinea. Little is known about its use; the Enga people who live in the area now have a tradition using stones which are said to be sacred.